Railways
South and West Scotland

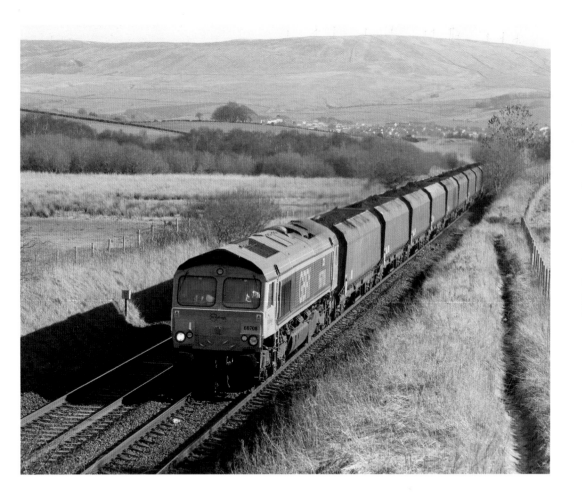

IAN LOTHIAN

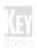

KEY
Books

BRITAIN'S RAILWAYS SERIES, VOLUME 28

Front cover image: On 4 April 2010, 37607 is at Stranraer, pushing railtour coaches into the now-disused platform.

Back cover image: With 43277 leading and National Railway Museum-liveried 43238 on the rear, the 07.30 Kings Cross to Aberdeen London North Eastern Railway (LNER) HST crosses Crawford Viaduct on 21 September 2019.

Title page image: 66708 passes Polquap on 18 March 2016 with one of the last regular merry-go-round (MGR) workings, removing coal stored at Greenburn and going to West Burton power station.

Contents page image: 70010 at Abington on 21 April 2010 with the 14.55 Ravenstruther to Drax loaded MGR.

Published by Key Books
An imprint of Key Publishing Ltd
PO Box 100
Stamford
Lincs PE19 1XQ

www.keypublishing.com

The right of Ian Lothian to be identified as the author of this book has been asserted in accordance with the Copyright, Designs and Patents Act 1988 Sections 77 and 78.

Copyright © Ian Lothian, 2022

ISBN 978 1 80282 163 5

Typeset by SJmagic DESIGN SERVICES, India.

Contents

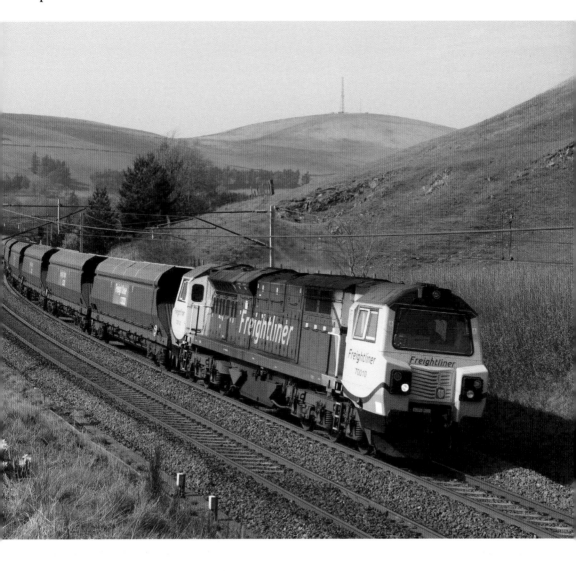

Introduction

After the raft of closures proposed in the Beeching Report were implemented, the south and west of Scotland were left with only the former Caledonian Railway's main line from the Central Belt to Carlisle, the modern West Coast Main Line (WCML), the former Glasgow and South Western Railway's (G&SWR) line from Kilmarnock to Gretna, the Glasgow–Ayr–Stranraer line and various lines around Ayr where coal was produced. One line that was closed, which most people will agree should never have been closed, was the 'Port Road', the line from Dumfries to Stranraer. Many also recognise that the former Waverley Route between Edinburgh and Carlisle should have remained, but at least it has been partially rebuilt and reopened between Edinburgh and Tweedbank, to the south of Galashiels. Now called 'The Borders Railway', there is hope that it will be extended at least as far as Hawick, which is the largest town in the Borders and one that, during periods where snowfall and bad weather affects the roads, does not enjoy good transport links to either the north or the south.

Although I have spent many years living in Central Scotland, the railway lines in the area covered in this book are ones that I know well. For many years, I had relatives in the northwest of England and frequently travelled from an early age on the WCML and, during the period when the WCML was being electrified in the 1970s, there were times when the trains I used were diverted south over the G&SWR, and, consequently, I have travelled many times on these lines. My wife, Irene, comes from Ayrshire, so, after we had met, I soon got to know the lines around Ayr and, especially, the line to Stranraer. Unfortunately, the passing of the years has not been kind to the Stranraer line; when I first encountered it, it had locomotive-hauled passenger trains to and from Glasgow and a daily through train to London that connected with the ferry from Stranraer to Northern Ireland. Those services soon were to end, and the locomotive-hauled trains were replaced by the Class 156 'Super Sprinters', as they were described when they initially entered service on the National Network. The steel trains to Stranraer ended in the very early 1990s, and once the ferries relocated from Stranraer to Cairnryan, passenger numbers using the line plummeted, yet the Stranraer line south of Ayr runs through some very lovely and, in places, sparsely populated countryside. Much more could be done to market its tourist potential, but the current infrequent basic passenger service certainly does not encourage anyone to use the line.

On all the lines covered by this book, it is amazing to look at how things once were and compare that with how things are now. For many years, freight, especially coal from numerous opencast sites left after the deep mines had closed, as well as from the deep-water port at Hunterston on the Clyde Coast, resulted in numerous coal trains running to power stations, not only in Scotland but also to many power stations in England. As a result of the daily procession of loaded coal trains going south, the G&SWR line was substantially upgraded at considerable expense, and yet, within just a few years, coal became environmentally unfriendly, and with the proliferation of wind turbines and worries about emissions and the climate, the coal traffic ceased. I have tried to show how it once was, how it is currently, and how it has changed by including a selection of my much older photographs as a comparison with the more recent images. This has not been an easy task and became more a case of what to leave out rather than what to include, as covering this area over a period of time within the scope of this book left me pondering, on many occasions, what should be included. The contents are

my interpretation, others would no doubt have done things differently, but I think I have achieved a balance between the then and now and hope that you, the reader, will appreciate this.

I have to thank all those who have helped me to be in the right place at the right time and for the welcome and friendliness I have encountered along this journey. My thanks go to those at Key Publishing, who have made this book possible, and to my family, especially Irene, who has been a tower of strength to me over the years and without whose help, this book would have remained a dream and not a finished product.

Ian Lothian
Larbert 2021

Late in the afternoon on 14 February 2000, 37610 and 37612 power south through New Cumnock with a 14.30 from Ayr Falkland Yard to Warrington loaded merry-go-round (MGR).

Chapter 1

The WCML south from Carstairs

The line south from Carstairs that forms today's WCML was built by the Caledonian Railway, which was formed at the end of July 1845. A link to lines that were built, or which were under construction, that would allow Edinburgh and Glasgow to connect with principal cities and markets in England was considered essential, and so the line was duly constructed and opened to traffic in 1848. Achieving this was made easier by the investment by so many shareholders who had shares in lines in England and who realised the potential in this extension. The Caledonian Railway did not place an emphasis on the word 'Caledonian', instead putting it on the word 'the'; in other words, although there were other railway companies in Scotland who were bitter rivals, this was *the* Caledonian Railway! The Caledonian formed an alliance with the London and North Western Railway (whose nickname was 'The Premier Line') and this gave the Caledonian access to London, Birmingham, Liverpool and Manchester – principal cities for passenger traffic and principal markets for freight.

As the line ran mainly through sparsely populated country, only two branch lines were built that were deemed to have any importance: Symington to Peebles, and Beattock to Moffat. The intention was not to cater for local traffic but rather for the long-distance market. Today, the line is served by several privatised passenger companies using modern rolling stock. Avanti West Coast uses a fleet of tilting Class 390 Pendolinos, while TransPennine, which runs from Edinburgh to Manchester Airport and from Glasgow to either Preston or Liverpool Lime Street, uses a small fleet of 12 five-car Class 397 EMUs built by CAF in Spain, the first of which only entered traffic in November 2019. There has also been a fundamental change in freight traffic, with intermodal container trains increasing in number, while over the past few years, the once-extensive coal traffic has ceased following closure of most of the former coal-fired power stations; the few that remain in use have been converted to burn biomass instead of coal. There is a daily fuel train that uses the line from Grangemouth to Dalston in Cumbria and return, and there is a cement train that runs between Mossend Yard and Clitheroe for Castle Cement. Although it is such a strategic line, it is severely underused, in large part because there are large gaps at times between trains, and when the volume of freight carried on the WCML is compared with that carried on the parallel M74 motorway, the WCML cannot compete with the near-constant stream of lorries going both north and south.

The introduction of the Class 66 locomotives from the late 1990s onwards could be seen as a turning point in modernising the rail freight industry. However, 20 years on, it is noticeable now how few freight trains are still being worked by a Class 66 locomotive. Freightliner's acquisition of the redundant ex-Anglia Class 90s has upgraded its motive power, with its former Class 86 locomotives now in store. Colas sold its Class 60 locomotives to GB Railfreight (GBRf) and now operate its services between Grangemouth and Dalston, and Aberdeen and Workington Docks with a US-built General Electric Class 70. The most impressive change, however, has been at the Carlisle-based Direct Rail

Services (DRS), where a small fleet of ten bi-mode Class 88s are now working on the Tesco intermodals between Mossend and Daventry, as well as other intermodal services. Being powerful enough to handle the longer and heavier trains with just a single locomotive, as well as being able to use the small onboard diesel engine for 'last mile' operation into freight yards where there are no overhead power lines, has meant that 99 per cent of the journeys using a Class 88 are now made using electric power. The use of diesel locomotives on long distance freight services where only the first and last miles are not wired was a regrettable position. The same applied to running long distance passenger services all the way under the wires but using a DMU instead of an EMU.

Those in charge of the upkeep of the track and infrastructure learned a harsh lesson at the end of 2015, when a torrential rainstorm over the Southern Uplands caused the level of the River Clyde to rise so quickly that the level and force of the flood waters seriously damaged the viaduct at Lamington by scouring a viaduct pier. With increasing periods of more severe weather, this is something that Network Rail will have to be prepared for, as, although they were lucky at Lamington, the potential for a disaster cannot be allowed to happen again. At nearby Crawford Viaduct, there are now two painted horizontal lines on the stonework of a pier. If the water level reaches the yellow mark, a speed restriction has to be put into operation, but if the water level rises further and reaches the red line, all rail traffic has to be stopped until the bridge can be inspected to ensure that it is safe.

The WCML has also seen several accidents. In April 1906, a goods train was shunting at Kirtlebridge and was partially on the main line when it was struck by an express passenger train. It was a signalling error due to no interlocking, but, unfortunately, 12 people were killed. Nothing was done to try to ensure there was no repeat, and, nine years later, at Quintinshill, because of severe negligence by two signalmen and a footplate crew, Britain's worst ever rail disaster occurred. A northbound passenger train was reversed over a crossover to clear the down main line for a northbound overnight express passenger. The local passenger train sat on the up main, and the signalman forgot about it and pulled off his signals for a southbound troop train. The resultant head-on accident was then compounded when the northbound express ran into the wreckage, and to make matters even worse, some of the old coaches used in the troop train were wooden bodied with gas lighting and caught fire, as did wagons of coal in a goods train in the adjacent loop. At least 226 people were killed, and a further 246 people were injured. At the end of this chapter, I have included a photograph of an accident also at Quintinshill; an axle on a wagon carrying timber broke, all 14 timber wagons were derailed, and both tracks were severely damaged. This time, when it happened, there was no other train going the other way, otherwise there could have been another major catastrophe at Quintinshill.

There is only one station open for passengers in the 73 miles between Carstairs and Carlisle, and that is at Lockerbie. Lockerbie is served mainly by TransPennine services, and, at the time of writing, it is also the only station in Scotland that is not served by ScotRail. There was a proposal several years ago to reopen a station at Beattock and for ScotRail to operate a Glasgow–Motherwell–Carluke–Carstairs–Beattock–Lockerbie and Carlisle service, but nothing came of that. In view of the effects of fewer people using the trains as a result of the COVID-19 pandemic, it is hard to visualise that such a service will be introduced, as it would certainly require financial support at what is currently a difficult time for passenger rail companies.

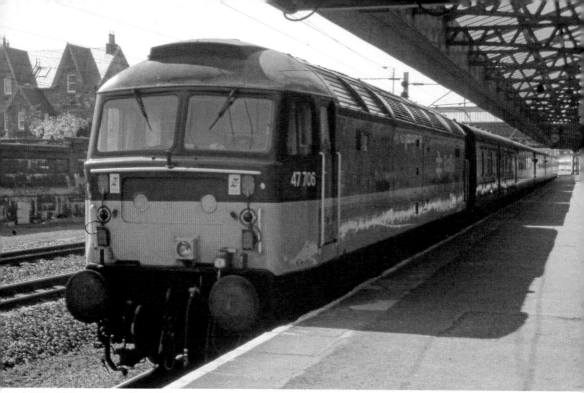

The old Carstairs station building was a substantial one, with all the amenities that one could expect at that time. On 7 May 1987, 47706 waits to depart with the Edinburgh portion of a service from Birmingham to both Edinburgh Waverley and Glasgow Central; the train was split at Carstairs.

After all the old buildings were demolished, a simple modern building was erected with a simple waiting room and basic staff accommodation for when staff are on site. The 12.00 Glasgow Central to Euston Pendolino, worked by 390109, passes 380103 working the 11.46 from Edinburgh Waverley to Glasgow Central at Carstairs on 27 February 2013.

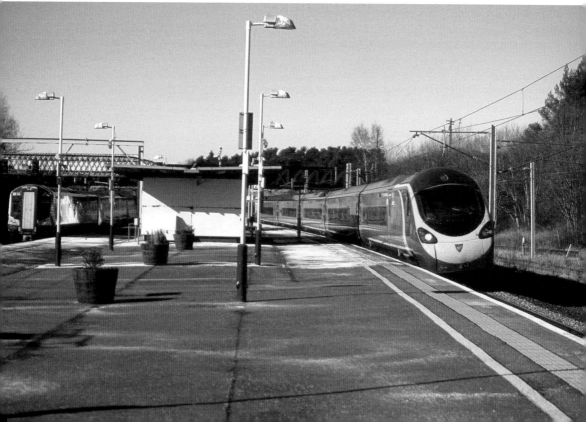

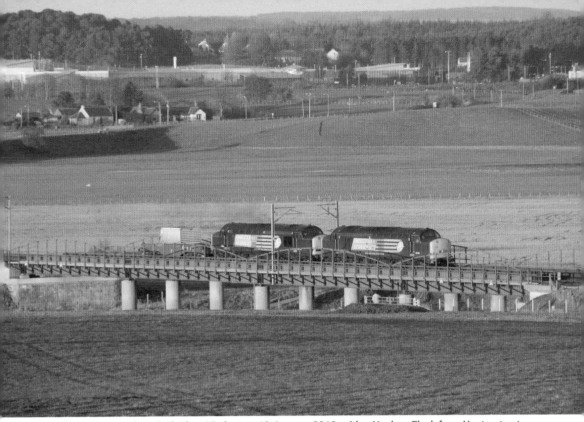

37601 and 37608 cross the rebuilt Float Viaduct on 13 January 2012, with a Nuclear Flask from Hunterston to Sellafield.

This is a photograph where I just happened to be in the right place at the right time! A Glasgow Central to Birmingham Class 221 Super Voyager is passed on the Float Viaduct by a Class 390 Pendolino with a Euston to Glasgow Central service on 7 June 2007.

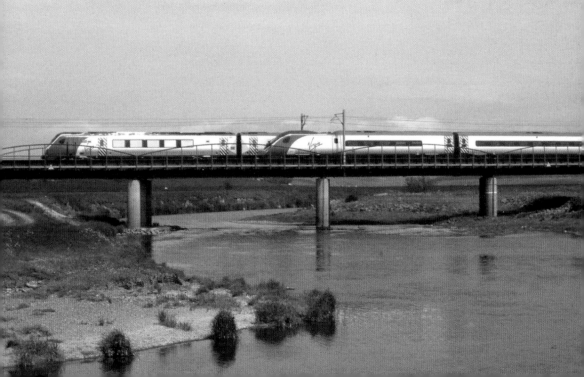

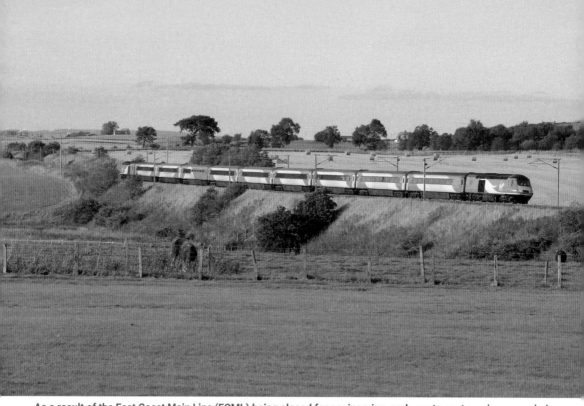

As a result of the East Coast Main Line (ECML) being closed for engineering work, east coast services were being diverted between Edinburgh and Newcastle to run via the West Coast Main Line (WCML) to Carlisle and then the Tyne Valley Line, regaining their normal route south at Newcastle. On 17 September 2016, the 13.52 Aberdeen to Kings Cross Virgin East Coast HST speeds south on the WCML at Thankerton.

60093 *Jack Stirk* runs north up the WCML at Lamington with the empty fuel tanks from Dalston (Cumbria) to Grangemouth on 19 April 2002.

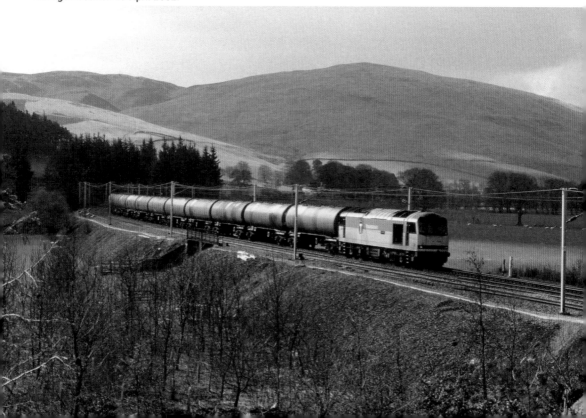

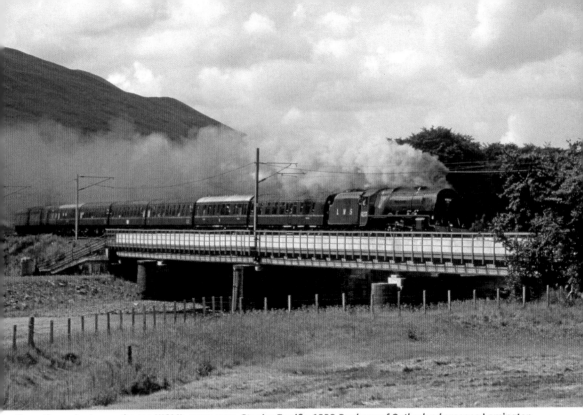

Once the mainstay on the top WCML expresses, Stanier Pacific 6233 *Duchess of Sutherland* crosses Lamington Viaduct on 13 July 2002, hauling a railtour from Carlisle to Glasgow Central.

A Virgin West Coast Euston to Glasgow Central crosses the River Clyde on Lamington Viaduct on 13 July 2002 behind Class 87 87006, a class that was designed for operating the West Coast expresses following the electrification of the line.

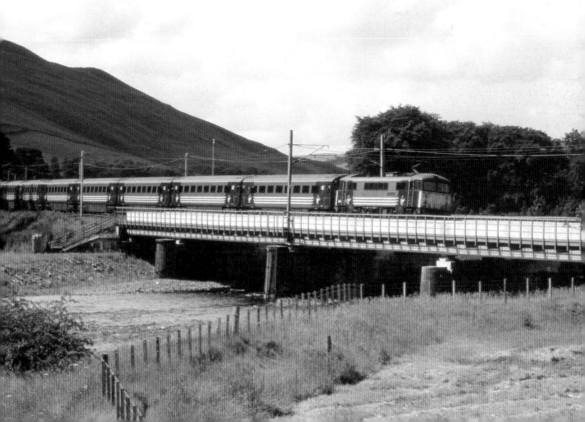

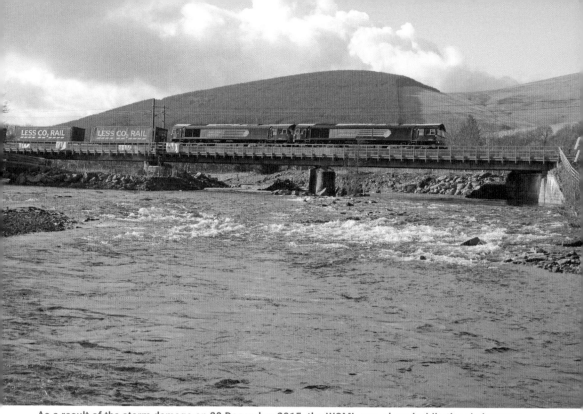

As a result of the storm damage on 30 December 2015, the WCML was closed while the viaduct was rebuilt. The first trains to use it when it reopened on 22 February 2016 had to cross at 10mph. The 06.23 Daventry to Mossend 'Tesco' intermodal slowly crosses the rebuilt viaduct behind 66432 and 66301 on 22 February 2016.

On 23 February 2016, 390153 crawls over the rebuilt viaduct at Lamington with the Virgin Trains West Coast 05.30 Euston to Glasgow Central service.

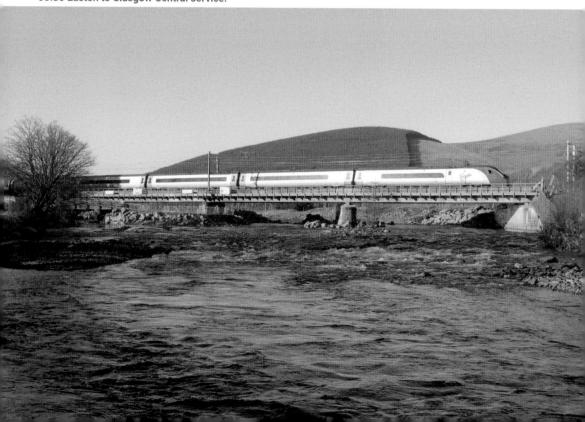

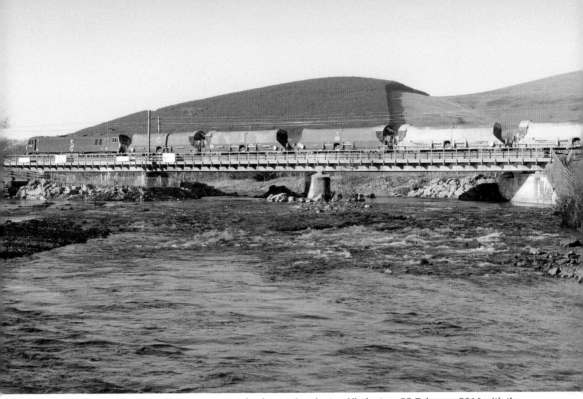

92033, in Caledonian Sleeper colours, runs very slowly over Lamington Viaduct on 23 February 2016 with the 08.22 Mossend to Carlisle Yard infrastructure working.

86222 speeds south on the WCML at Wandel, to the north of Abington, with the 09.10 Edinburgh to Bournemouth Virgin CrossCountry service on 19 April 2002. This was almost at the end of the use of the Class 86s and their seven-coach trains, as, shortly after this was taken, the CrossCountry services went over to being worked by the Voyager Classes 220 and 221.

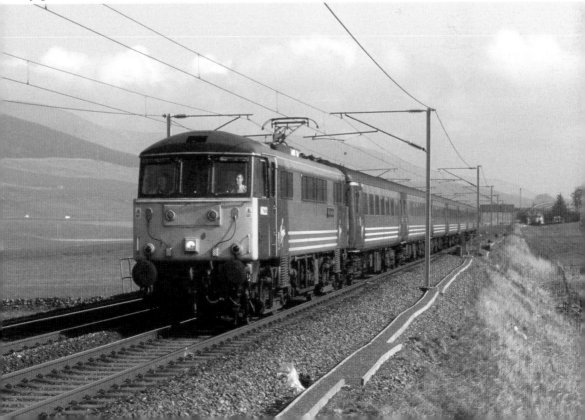

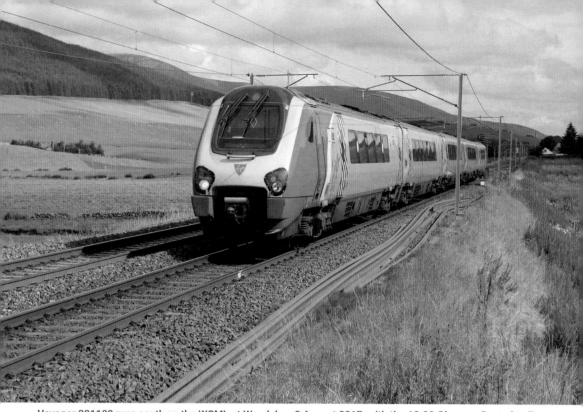

Voyager 221102 runs south on the WCML at Wandel on 8 August 2017, with the 10.00 Glasgow Central to Euston via Birmingham New Street.

350404 is working the 09.07 Glasgow Central to Manchester Airport, when it passes Wandel in the Upper Clyde Valley on 21 September 2019.

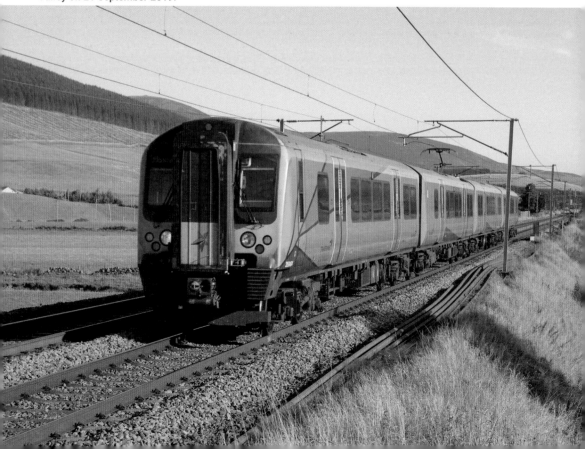

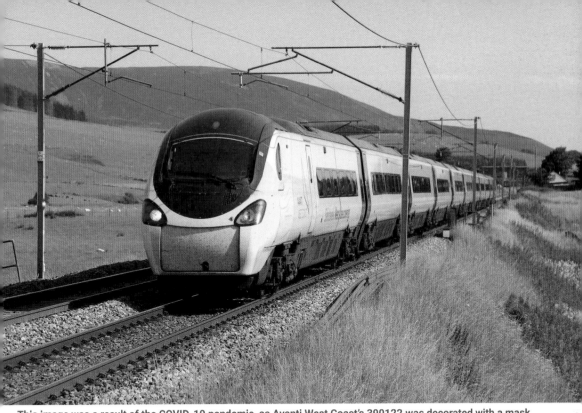

This image was a result of the COVID-19 pandemic, as Avanti West Coast's 390122 was decorated with a mask on each end to help to get the 'wear a mask' message over to travellers. On 31 July 2020, it passed Wandel while working the 09.40 from Glasgow Central to Euston.

Each year, there are several stock moves between Carnforth and Fort William in connection with the running of the 'Jacobite' steam tourist service between Fort William and Mallaig. On 18 May 2004, a Carnforth to Fort William empty coaching stock move was also used to move Standard Class 4 2-6-0 76079 north with 37197 behind, in case of any problems that might arise en route.

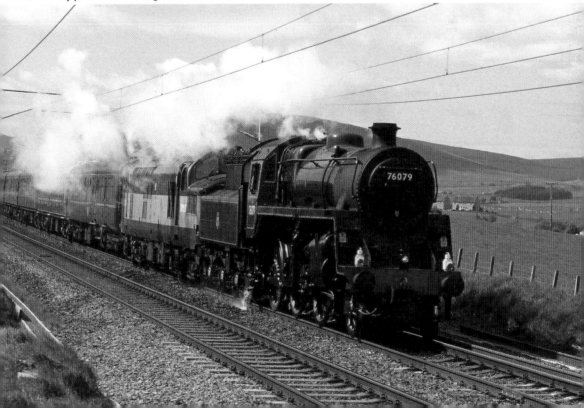

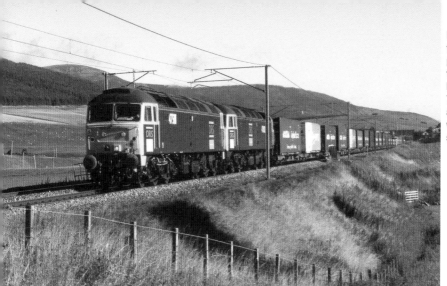

For a short period, DRS trialled the use of a pair of its Class 47s on the 08.21 Mossend to Daventry intermodal. On 7 September 2006, 47501 and 47802 passed Wandel with the fully loaded service to Daventry.

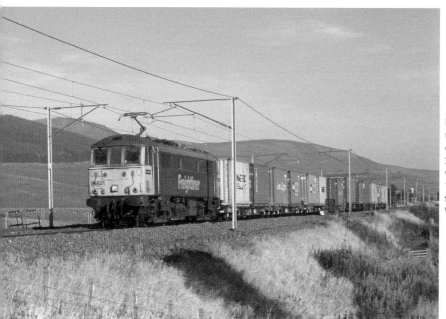

Freightliner's Class 86s usually worked in pairs on the WCML but on 24 October 2007, 86621 was in sole charge of the 10.31 from Coatbridge to Crewe Basford Hall at Wandel.

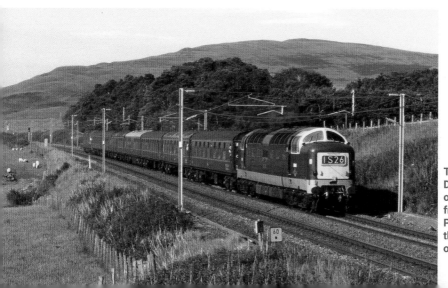

Top 'n' tail Deltics! With D9009 leading and 55019 on the rear, the 10.51 from Fort William to Preston speeds south on the WCML at Wandelmill on 26 June 2003.

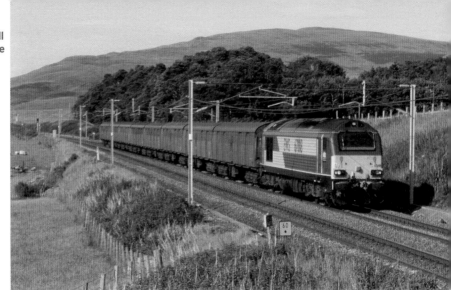

67018 passes Wandelmill on 26 June 2003, with the 17.30 empty vans from Motherwell to Walsall for the then-overnight high-speed parcels service to Aberdeen.

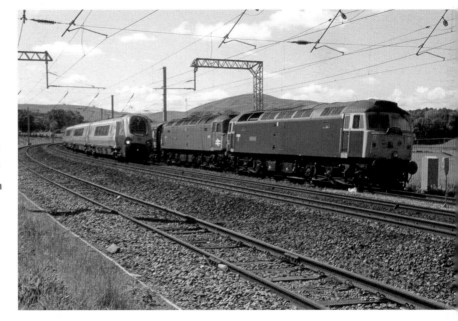

47839 and 47853 wait at Abington loop on 31 May 2008, with a Compass Railtour from Holyhead to Edinburgh, and 221113 speeds past with a Birmingham to Edinburgh Virgin CrossCountry service.

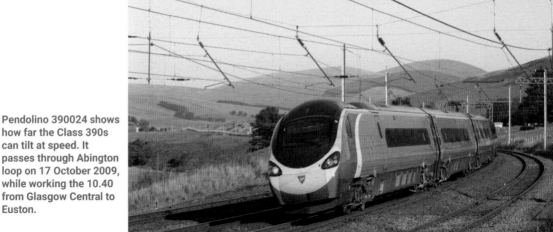

Pendolino 390024 shows how far the Class 390s can tilt at speed. It passes through Abington loop on 17 October 2009, while working the 10.40 from Glasgow Central to Euston.

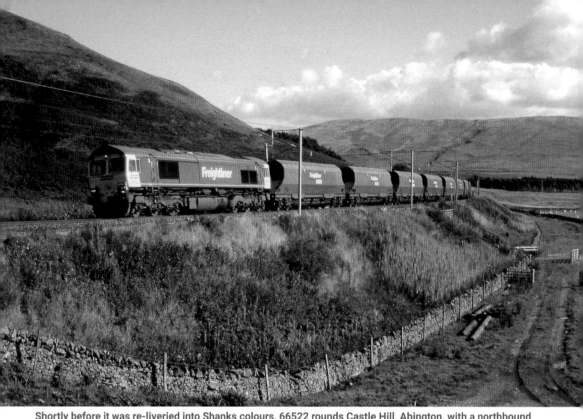

Shortly before it was re-liveried into Shanks colours, 66522 rounds Castle Hill, Abington, with a northbound empty MGR from Wintersett to Hunterston on 15 September 2004.

The Class 325 Royal Mail EMUs had to be loco hauled for many weeks in 2005 because of a technical problem. On 22 August 2005, the 16.20 Shieldmuir to Warrington rounds Castle Hill, Abington, with 87012 *Back the Bid* hauling 325004 and 325014.

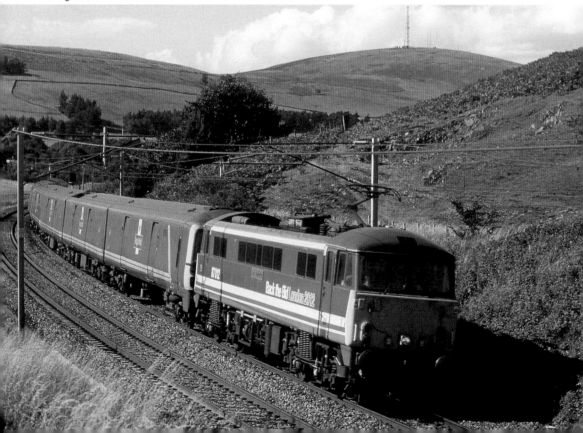

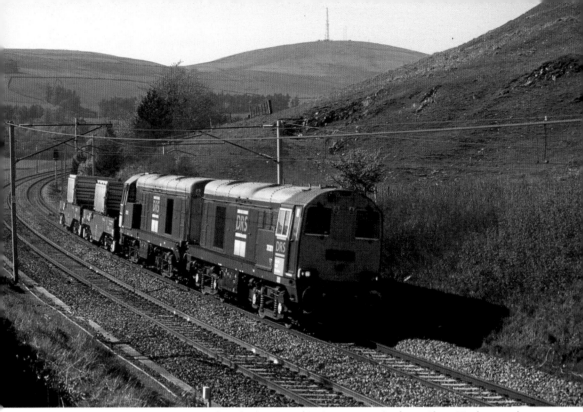

The usual power for a Hunterston to Sellafield flask train at this time was a pair of DRS Class 37s, but, much to my surprise, on 13 May 2008, the train was hauled by two Class 20s. 20301 and 20305 are south of Abington with two flasks from Hunterston.

390117 works the 14.53 Edinburgh Waverley to Euston Avanti West Coast service on 18 May 2021. The full set is in its new Avanti livery as it tilts round Castle Hill, south of Abington.

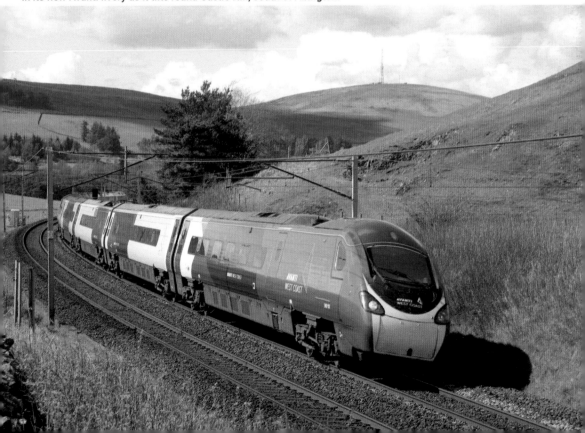

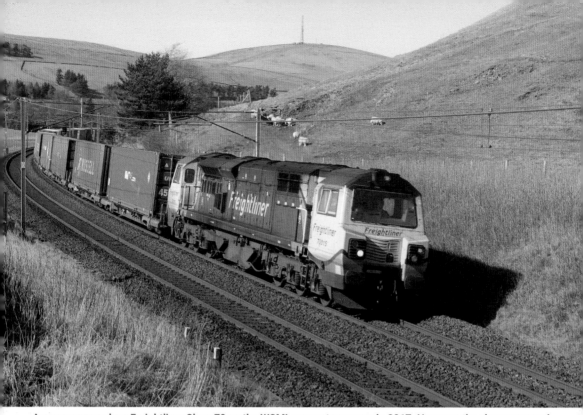

Any appearance by a Freightliner Class 70 on the WCML was not common in 2017. However, the class was used for a short time on the Sunday afternoon Freightliner service from Coatbridge to Crewe and, on 26 March 2017, 70015 powers south along the WCML south of Abington with the Coatbridge to Crewe Basford Hall intermodal.

92009 with Railfreight Distribution branding runs south on the WCML between Abington and Crawford on 15 September 2004, with empty china clay tanks from Mossend to Carlisle Yard.

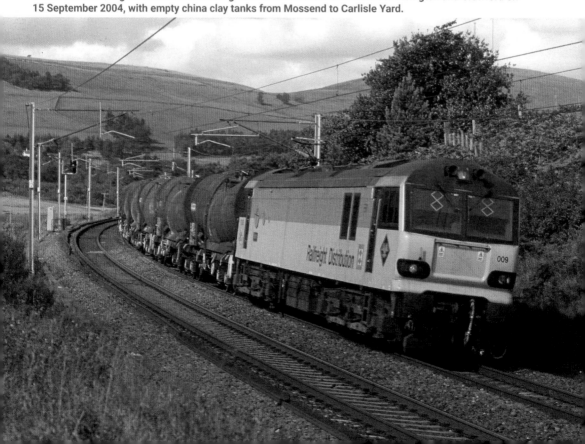

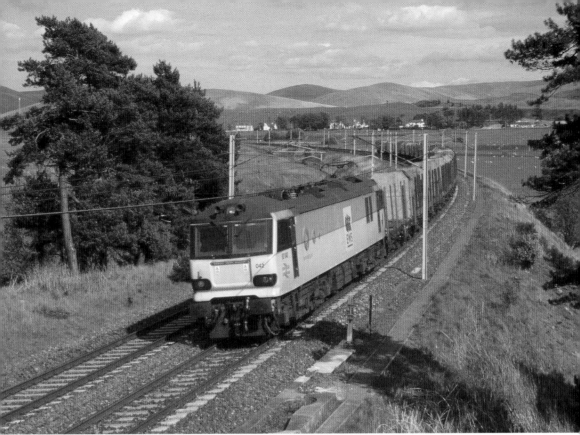

92042 is travelling north between Crawford and Abington on 31 May 2006, with a lengthy rake of empty OTA timber wagons from Carlisle Yard to Mossend.

66165 approaches Crawford with the 09.46 Grangemouth to Daventry intermodal on 21 September 2019.

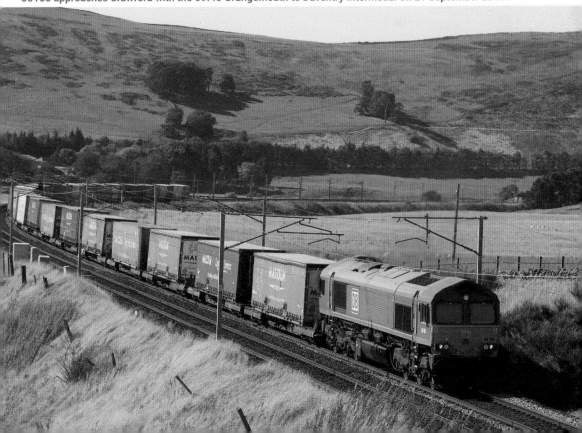

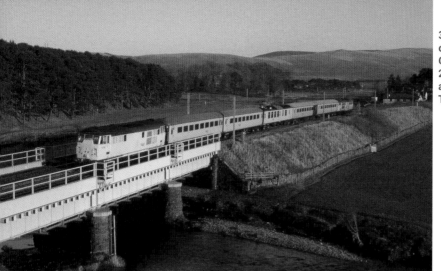

31105, with 31233 on the rear, crosses Crawford Viaduct on 29 December 2008 with a Derby to Mossend Test Train.

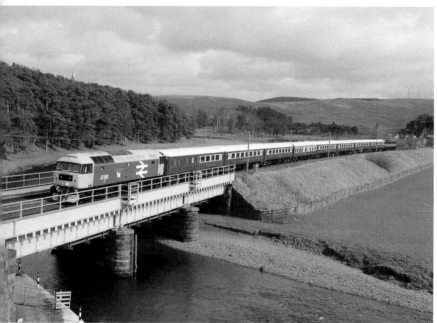

47593, with green D1944 on the rear, is working a Milton Keynes to Fort William charter on 23 March 2019, as it crosses Crawford Viaduct. Here, you can see the red and yellow lines painted onto the viaduct to monitor water levels.

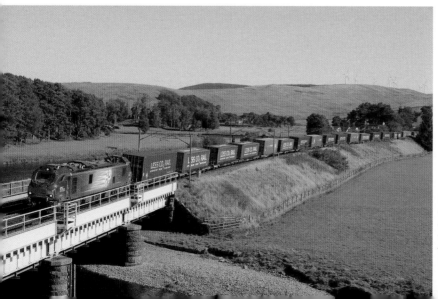

DRS Class 88 88003 crosses Crawford Viaduct on 21 September 2019 with the 06.40 Daventry to Mossend 'Tesco' intermodal.

Diverted to run via the Tyne Valley line and the WCML because of the closure of the ECML, 66736 leads the 07.14 North Blyth to Fort William loaded alumina tanks over Crawford viaduct on 21 September 2019.

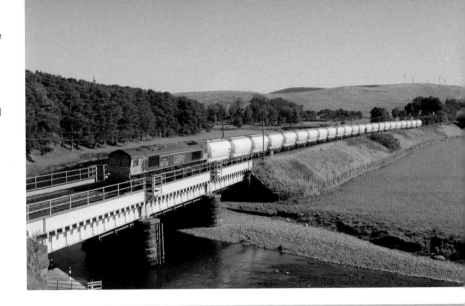

800109 crosses Crawford viaduct on 21 September 2019, with the diverted 08.24 Kings Cross to Edinburgh Waverley London North Eastern Railway (LNER) service.

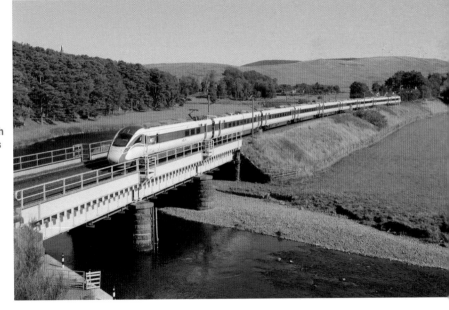

With all of its Virgin branding removed from the coaches, except for that on the two end cars, 390135 crosses Crawford Viaduct on 21 September 2019 with the 08.30 from Euston to Glasgow Central.

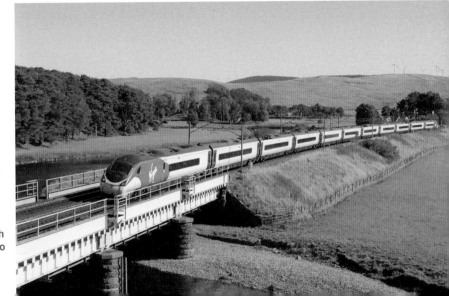

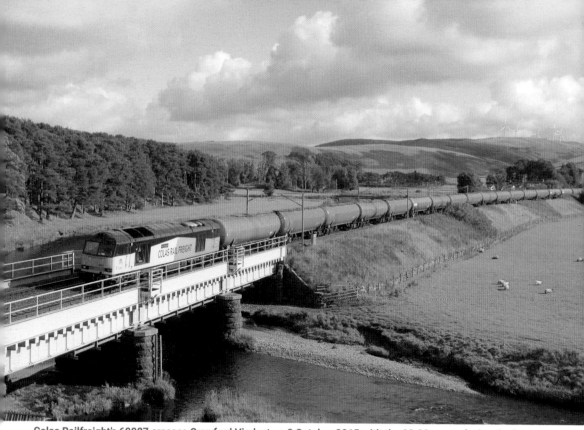

Colas Railfreight's 60087 crosses Crawford Viaduct on 8 October 2015 with the 08.32 empty fuel tanks from Dalston to Grangemouth.

By the autumn of 2019, Class 70s had taken over hauling the Dalston tanks, and on 21 September 2019, 70806 crosses Crawford Viaduct with the 08.32 from Dalston.

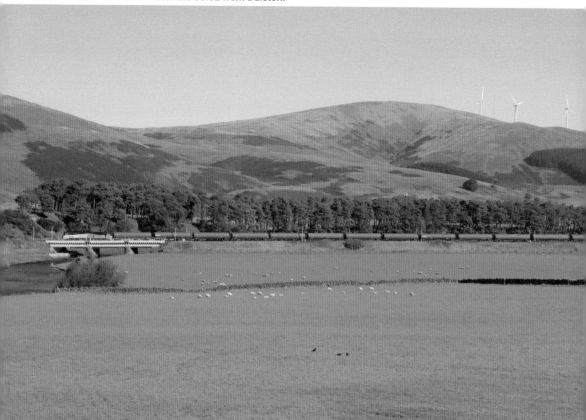

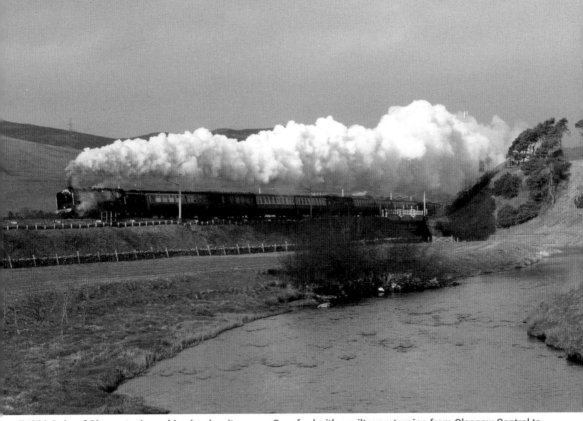

71000 *Duke of Gloucester* is working hard as it passes Crawford with a railtour returning from Glasgow Central to Kings Cross on 16 April 2008.

On 17 September 2016, 91125 runs south on the WCML at Crawford with the diverted 15.42 from Edinburgh Waverley to Kings Cross.

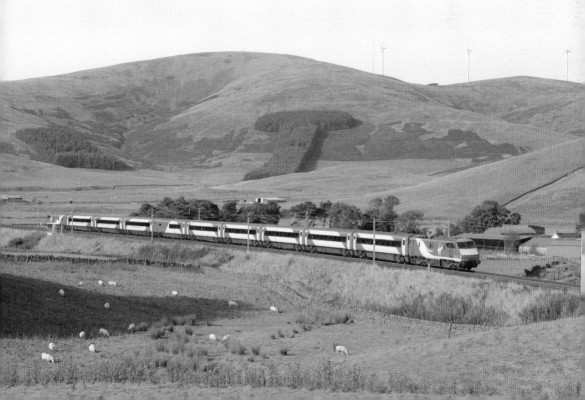

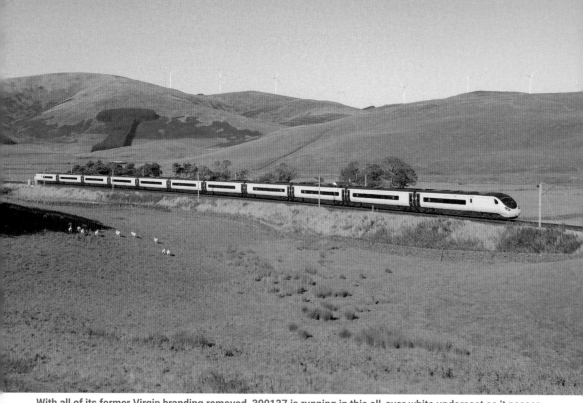

With all of its former Virgin branding removed, 390137 is running in this all-over white undercoat as it passes Crawford on 21 September 2019 with the 14.40 from Glasgow Central to Euston.

Unusually worked by just a single four-car Class 325, the 16.40 Shieldmuir to Warrington Royal Mail service passes Crawford on 8 April 2011.

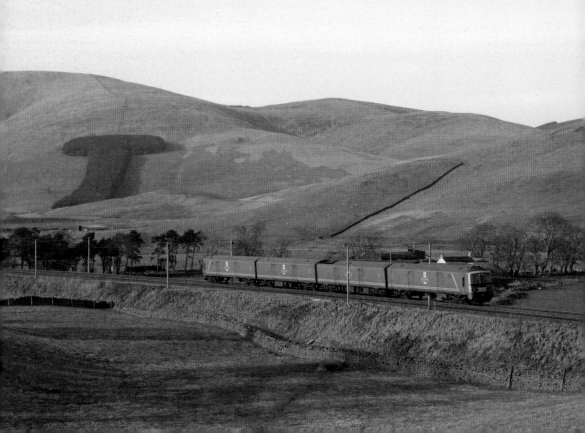

On 22 November 2001, in dramatic light just before the onset of a severe thunderstorm, the 10.40 Edinburgh Waverley to Brighton Virgin CrossCountry service runs south on the WCML at Elvanfoot with 47746 leading 86251.

DVT (driving van trailer) 82201 leads the diverted 11.00 Kings Cross to Edinburgh Waverley, with 91129 pushing on the rear as the train passes Elvanfoot on 17 September 2016.

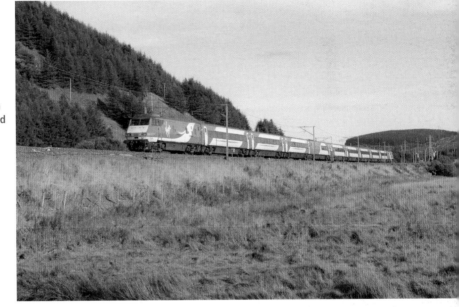

Another empty stock working from Carnforth to Fort William for use on the Jacobite steam tourist service between Fort William and Mallaig is captured on 25 May 2006 as Class B1 61264 climbs Beattock Bank at Greenhillstairs.

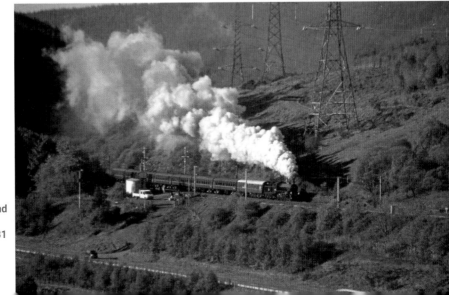

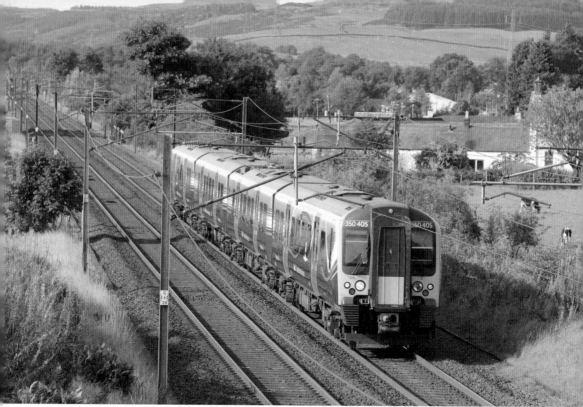

In its 'Dynamic Lines' TransPennine Express livery, 350405 is photographed just south of Beattock village on 17 September 2016, working the 15.09 Glasgow Central to Manchester Airport.

397003 arrives at Lockerbie, the only station in Scotland not served by ScotRail services, on 27 May 2021, with the 12.04 Glasgow Central to Liverpool Lime Street TransPennine service.

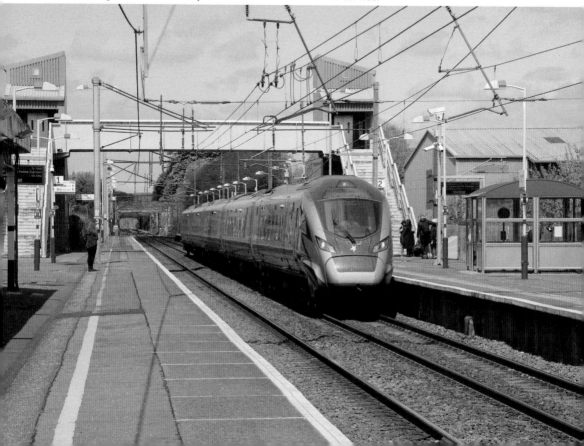

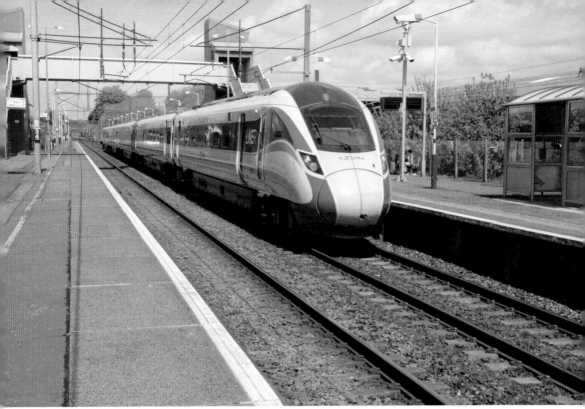

Running as an 11.17 Edinburgh Waverley to Leeds Neville Hill empty stock route-learner, 800205 passes through Lockerbie at speed on 27 May 2021.

On 17 June 2002, an axle broke on an OTA loaded timber wagon on a Mossend to Chirk timber train at Quintinshill, just north of Gretna, causing all 14 wagons to derail and spill their loads of timber. This caused severe damage to both the track and the overhead power lines, and the WCML was closed while repairs were carried out. A shuttle service of trains ran between Lockerbie to both Edinburgh and Glasgow, with buses used between Lockerbie and Carlisle. On the day after the accident, 18 June 2002, Voyagers 221107 and 221116 arrive at Lockerbie from Edinburgh Waverley before then working a 10.20 back to Edinburgh. A British Transport police officer kept a good watch as I took the photograph!

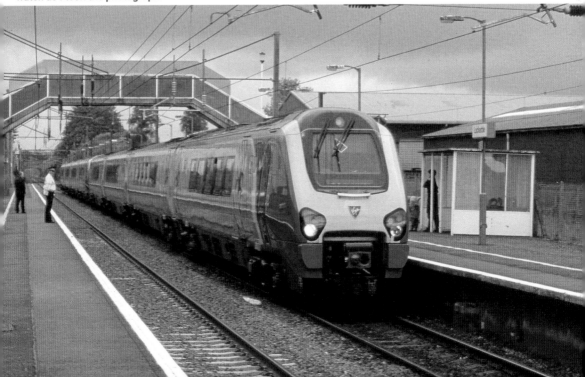

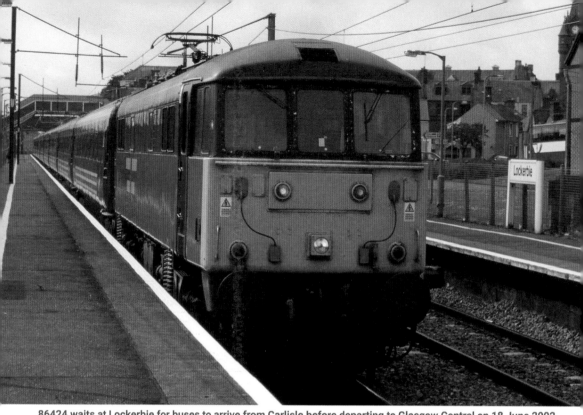

86424 waits at Lockerbie for buses to arrive from Carlisle before departing to Glasgow Central on 18 June 2002.

A day after the accident, this is the scene at Quintinshill on 18 June 2002; the derailed wagons and the extensive damage to the tracks and overhead masts and wires can be clearly seen. The timber was being moved to the sides of the lines so that the damaged OTA timber wagons could then be removed to enable track repairs to commence.

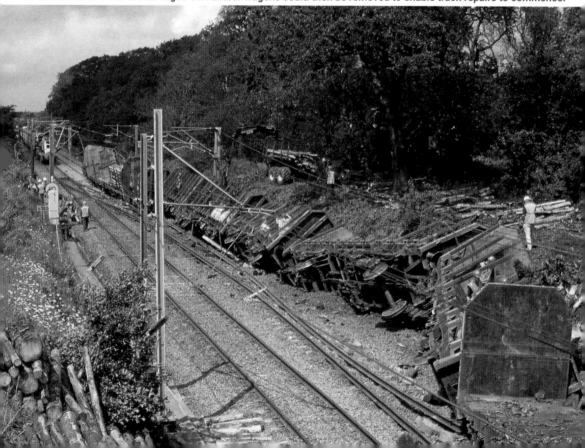

Chapter 2
The Borders Railway

The original Waverley Route ran through the Borders from Edinburgh to Carlisle. It was built in two stages by the North British Railway – Edinburgh to Hawick opened in 1849 and the remainder of the line from Hawick south to Carlisle in 1862. By the early 1960s, when car ownership and the road haulage industry were both expanding, passenger numbers and the volumes of freight being carried were falling, and in the 1963 Beeching Report on the reshaping of the British Railway Network, the line was recommended for closure. Despite numerous objections and petitions, the line finally closed on 6 January 1969, and, over the next few years, it was dismantled in stages and parts of the former trackbed were sold off. British Railways had argued that through traffic between Edinburgh and Carlisle could easily be transferred to run via the WCML, and that is what happened.

The closure left the Borders as one of the largest areas not served by a railway in Scotland, and, by the start of this century, there was a spirited campaign for at least part of the line to be rebuilt. The project eventually received Royal Assent in June 2006, and, after much debate and modifications to the initial plans, construction of the Borders line between Newcraighall and Tweedbank, to the south of Galashiels, commenced towards the end of November 2012. The line was built to be a basic, predominantly single-track line that was 31 miles in length; it featured three short sections of double track called dynamic loops, where trains could pass without either having to stop and wait for one to clear the next section of single track. Although the line was the subject of numerous economies, it was at least built with sufficient clearances throughout, which would ensure that no further work would be required to overbridges if the line was to be electrified at some stage.

Seven new stations were constructed at Shawfair, Eskbank, Newtongrange, Gorebridge, Stow, Galashiels and Tweedbank, the current terminus of the line. I use the word 'current' as there is a demand to extend the line to Hawick, the largest town in the Borders and where surrounding roads can very easily be affected by adverse winter conditions. Time will tell if this is to happen, but it is something that *should* happen. When the line was being debated prior to construction starting, various 'experts' advised the politicians that it would only be low numbers that would use the line. A maximum estimate of 650,000 journeys per year was made, but this was passed within six months. The line has been a huge success, and before the COVID-19 pandemic, the line's usage was running at around 1.5 million passenger journeys per year – far more than ever estimated. Hopefully, the line will be extended to Hawick, as it would bring many economic benefits to that area of the Borders.

Before COVID, the line enjoyed a half hourly service, but with fewer numbers currently using the trains, the service frequency has been reduced to half hourly only during the morning and evening peaks, with an hourly service then throughout the day and in the evenings. Trains are formed by either two-car Class 158s or three-car Class 170s, although at times of high demand, such as when there is a Rugby International match at Murrayfield, six-car trains have been run. The line is not the easiest one to operate; after departing south from Eskbank, the climb to the summit at Falahill begins with a ruling grade of 1 in 70. Falahill summit is at a height of 880ft, which is only 35ft lower than that of the well-known Shap Summit on the WCML in Cumbria. From the south, the final miles to Falahill are at 1 in 88, and the summit is unremarkable in that it is just open moorland, not at all spectacular in views like some railway summits. It was these gradients, as well as an equally severe climb from Hawick to

the next summit at Whitrope, that in many ways sealed the fate of the original Waverley Route, as in steam days, double heading of goods trains was common, with banking engines also having to be used at times, ultimately contributing to much higher running costs.

There were initially several problems with the signals, which resulted in numerous delays and cancellations; the usage of a single two-car Class 158 on some services also caused overcrowding issues, and the lack of any facilities other than the most basic waiting shelters at stations, lack of ticket machines and not nearly enough car parking spaces highlighted that, when costs are cut, problems arise. One bad decision was that overbridges were built with only single line clearances, when they could easily have been built to double track width to cater for any future need to either expand the lengths of the double track sections or to provide another passing loop. Bridges over streams and rivers were also rebuilt to single track specification, which would make any doubling of the track in the future a much more expensive project. In my opinion, the final mistake was that when Tweedbank station was built, it was built as an island platform long enough to accommodate a ten- or 11-coach excursion train, but without any run-round facility, so any loco-hauled train running to Tweedbank has to have another locomotive on the rear to return the train to Edinburgh. This removed the potential for excursion trains to travel over the line and bring additional tourist traffic to the area. On the whole length of the line, there are only seven sets of points: one at each end of the three dynamic loops and one at Tweedbank. The project was scaled back, in large part thanks to reports that it would not be well used, and, therefore, there was the need to construct it as cheaply as possible.

On 8 June 2015, 158741 passes Bowland on a driver route-learning run from Tweedbank to Newcraighall (the then limit of passenger services from Edinburgh Waverley).

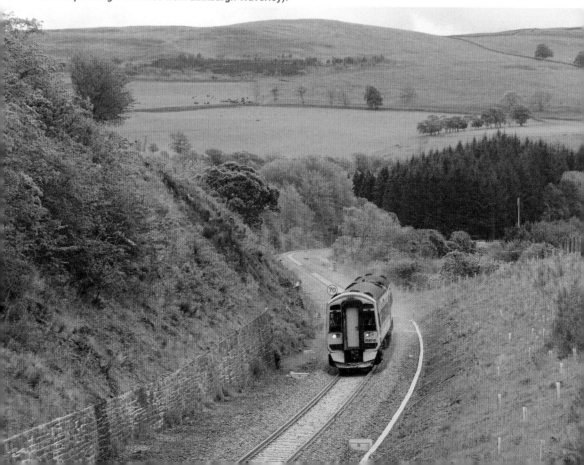

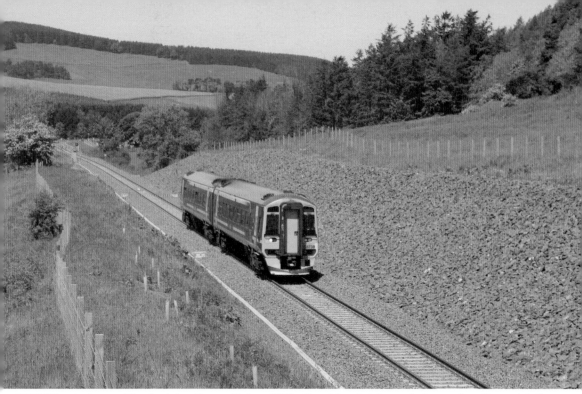

158738 has just passed Bowland Junction on 11 June 2015 with a driver training route-learner from Newcraighall to Tweedbank.

170414, in its special Borders line promotional livery, climbs past Tynehead with the media special from Edinburgh Waverley to Tweedbank for the opening ceremony of the line on 9 September 2015.

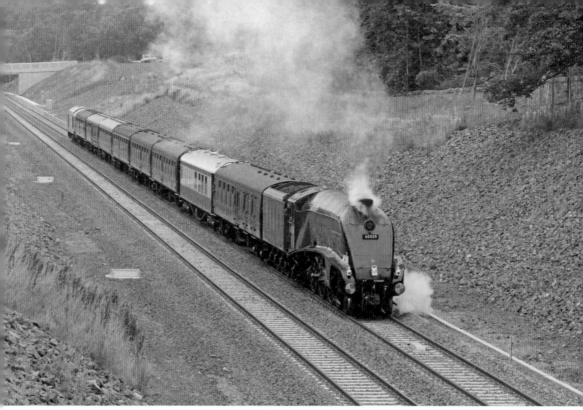

Class A4 Pacific 60009 *Union of South Africa* is hauling the Royal Train as it carries Her Majesty The Queen from Edinburgh Waverley to Tweedbank. It is seen climbing past Tynehead on 9 September 2015.

67026 returns the empty stock of the Royal Train from Tweedbank to Millerhill Yard on 9 September 2015; 60009 is on the rear because of the lack of any run-round facility at Tweedbank. 67026 is nearing Heriot on the southern approach to Falahill Summit.

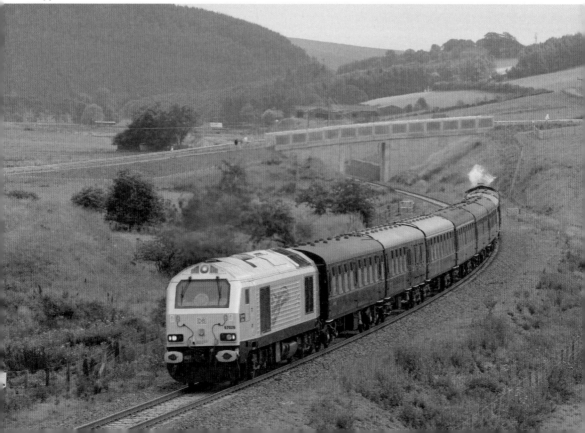

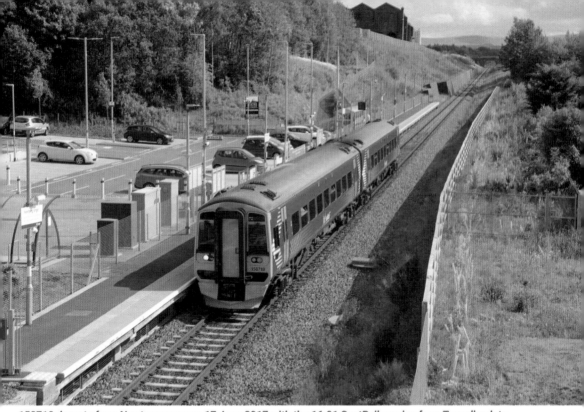

158710 departs from Newtongrange on 17 June 2017 with the 16.01 ScotRail service from Tweedbank to Edinburgh Waverley.

158789 passes the site of the former Lady Victoria Colliery (now the home of the Scottish Mining Museum) at Newtongrange on 13 August 2017, with the 11.12 from Edinburgh Waverley to Tweedbank. It is difficult to visualise that this location was once a double-track main line with extensive sidings.

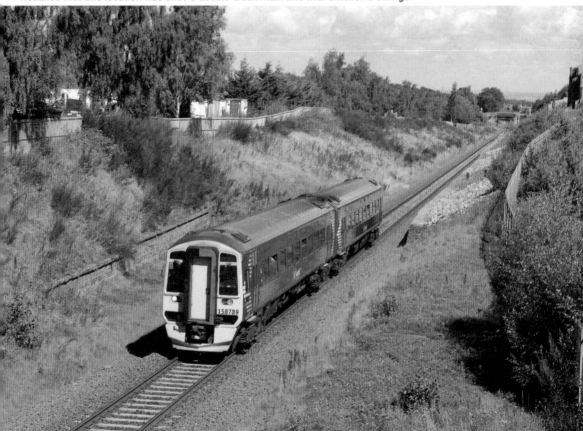

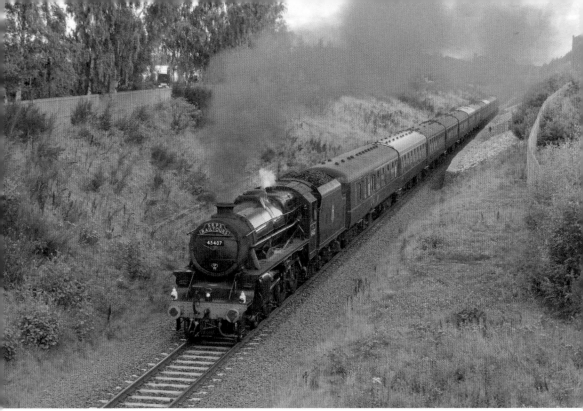

Black 5 45407 roars past Lady Victoria on 13 August 2017 with the 08.53 Linlithgow to Tweedbank Scottish Railway Preservation Society (SRPS) Railtour.

158710 is about to depart from Gorebridge with the 14.53 from Edinburgh Waverley to Tweedbank on 17 June 2017. Gorebridge has one long platform beside the single-track line; trains to Edinburgh depart from the north end, while services to Tweedbank call at the south end.

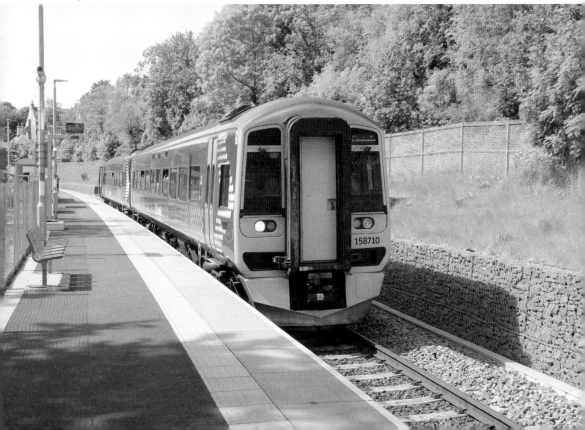

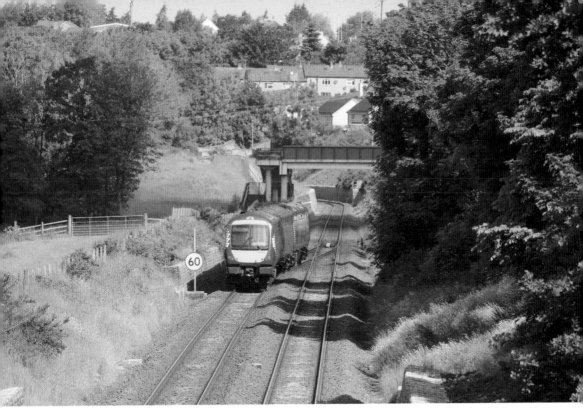

170413 passes the site of Fushiebridge Junction and enters the single track on the approach to Gorebridge with the 09.29 from Tweedbank to Edinburgh Waverley on 22 June 2021. The double-track dynamic loop runs for 3.8 miles from Fushiebridge to Tynehead Junction, enabling trains to pass without having to stop. In the original plans, this dynamic loop was to have been considerably longer, but that plan was abandoned, and the double-track section became much shorter in order to save money on a project that the then Scottish government would have liked to have cancelled altogether.

Another Black 5, 44871, climbs upgrade at Tynehead with the 08.52 SRPS Railtour from Linlithgow to Tweedbank on 25 August 2019.

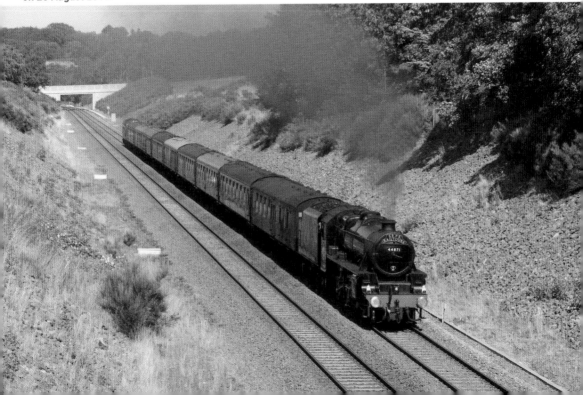

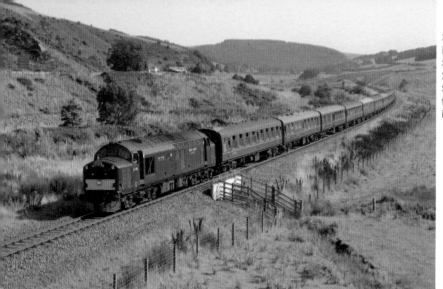

37685 climbs the 1 in 88 gradient to Falahill Summit near Heriot on 25 August 2019 with the SRPS Railtour returning from Tweedbank. 44871 is on the rear.

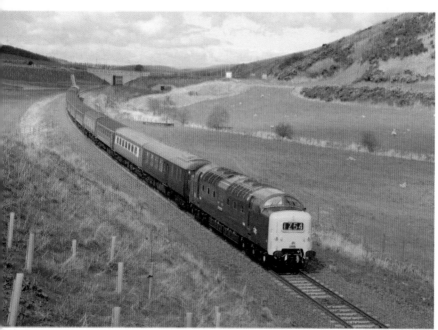

With Class 67 67015 on the rear, Deltic D9009 passes Hangingshaw on 9 April 2016 with the 04.55 Derby to Tweedbank railtour.

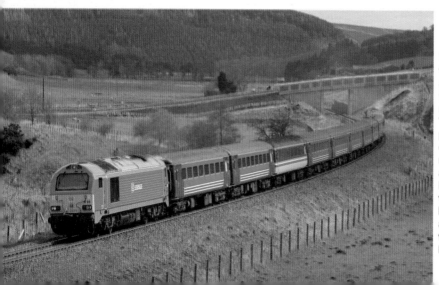

With D9009 now on the rear, 67015 is approaching Heriot on 9 April 2016 with the railtour returning from Tweedbank to Derby. As part of the cuts to the original plans, there are no run-round facilities at Tweedbank, so any locomotive that takes a train to Tweedbank has to have another locomotive at the opposite end of the train to return it to Edinburgh.

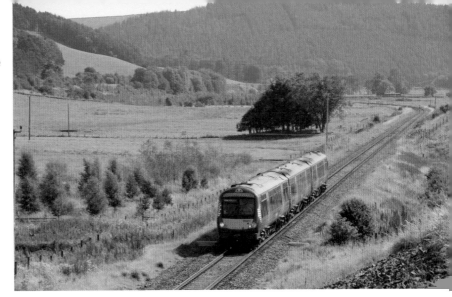

170451 is approaching Hangingshaw on 25 August 2019 with the 13.45 ScotRail service from Tweedbank to Edinburgh Waverley.

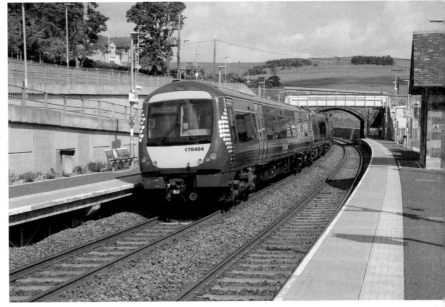

170404 calls at Stow on 22 June 2021 with the 10.28 from Tweedbank to Edinburgh Waverley. Stow is on the third and last double-track section, which runs for just over three miles between Galabank Junction and Bowland Junction; this was another length of double track that was reduced in length to cut costs.

170417 arrives at Galashiels on 2 March 2020 with the 10.54 from Edinburgh Waverley to Tweedbank. Galashiels was a substantial three-platform station on the former Waverley line, but after the line was closed in 1968, a new road was constructed on the former trackbed, and, when the Borders line was rebuilt, there was only room for a single-track railway and a narrow platform with a small waiting shelter.

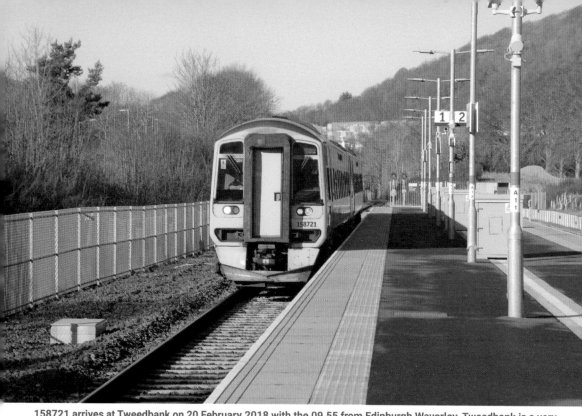

158721 arrives at Tweedbank on 20 February 2018 with the 09.55 from Edinburgh Waverley. Tweedbank is a very basic station with a very long island platform but only two very basic waiting shelters, a ticket issuing machine and no other facilities.

A pair of Class 170 DMUs are seen at Tweedbank on 2 March 2020. 170396 will eventually work the 16.30 to Edinburgh Waverley, while 170417, a unit no longer with ScotRail, will shortly be departing with the 12.01 to Edinburgh Waverley.

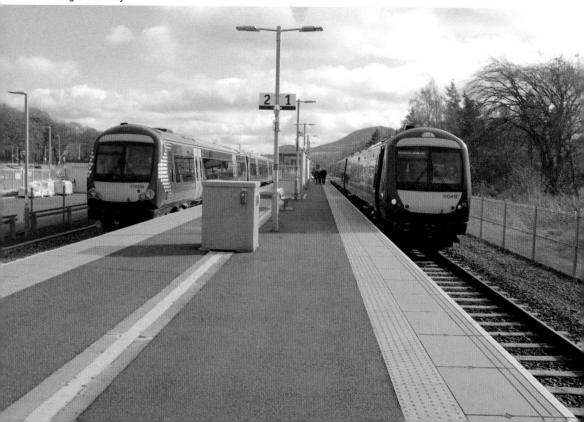

Paisley to Ayr and the Clyde Coast lines

In the 19th century, many of the most successful and influential Glaswegian businessmen had homes on the Isle of Bute and commuted from Rothesey to Glasgow. The ideal location of a port for a ferry to run between the Isle of Bute and the mainland was at Wemyss Bay, and the railway duly arrived there in 1865, as the Wemyss Bay Railway, and enjoyed a separate identity until the beginning of August 1893, when it was finally absorbed into the Caledonian Railway. The line left the route to Greenock at Wemyss Bay Junction, to the west of Port Glasgow station, and travelled to the south side of Greenock before descending to the coast via Inverkip. The Caledonian had reached Paisley from Glasgow as early as 1840, and the line from Paisley to Greenock had opened in 1841. However, Greenock was not ideally situated to be a successful ferry terminal, and so the line from Greenock was extended to Gourock, the present terminus, but was not opened until 1889. This line still has the longest rail tunnel in Scotland: Newton Street Tunnel comes in at 1 mile and 350 yards in length between Greenock West and Fort Matilda. After building the new terminus at Gourock, a three-platform station on a sharp curve, the Caledonian Railway decided that they would build a much more splendid station at Wemyss Bay. James Miller was the architect and was told to make it 'special', and, as a result, Wemyss Bay station is now a Category A listed building, renowned for the intricate and ornamental ironwork in its overall roof.

Wemyss Bay station incorporated a new ferry terminal, and as speed was considered desirable, the station was designed with spacious passageways so that passengers coming off a boat and going for a train would not get in the way of passengers getting off the train and going to catch the boat. By advertising good connections, the Caledonian intended to stop any incursion for ferry passengers by its great rival, the G&SWR, which had ferries operating from its terminus at Princes Pier, Greenock. Wemyss Bay originally had two long island platforms, but the tracks to one of them have been lifted and it is now just a two-platform station without a run-round facility. Consequently, when the Royal Scotsman, the luxury tour train, visits Wemyss Bay, it requires a locomotive to be at each end of the train before it can depart.

The line between Glasgow and Paisley was a joint line between the Caledonian Railway and the G&SWR. At Paisley Gilmour Street station, the two companies' lines go their separate ways: the Caledonian line to Wemyss Bay and Gourock and the G&SWR to Ayr. As can be seen in the image on page 42, Paisley Gilmour Street used to have canopies over each of its four platforms, which had been rebuilt in the mid-1970s, but the station received a new overall roof built between 2010 and 2012, and the new roof can be seen on page 44.

The first major change to services came in 1967, when the Inverclyde lines to Gourock and Wemyss Bay were electrified, and British Railways ordered new Class 311 EMUs to work the improved services. The line to Ayr was not electrified until 1986, when a new fleet of Class 318 EMUs were ordered to work the services. From Paisley, the line runs westwards before turning towards the south and running towards Kilwinning and Irvine. Kilwinning is the junction for the lines and services to Ardrossan Harbour and Largs. Paisley to Kilwinning was built in 1840, and the line to Fairlie was opened in 1880 and then extended on to Largs in 1885. This was a double-track line, but, when it was electrified, it was

singled through Fairlie to Largs. On 11 July 1995, the early morning 06.15 from Glasgow Central to Largs, formed by 318254 and 318262, suffered braking failure and smashed into the buffers, overshooting the end of the platforms, demolishing many of the station buildings and shops on the other side of the station and ending up in the main street in Largs. Thankfully, as the accident occurred at 07.15, when there were few pedestrians and many of the shops were still closed, there were few casualties. The original station buildings had to be demolished, and a small temporary booking office was built, lasting until a replacement building was constructed in 2002. The line to Ardrossan Harbour was only built as recently as January 1987, as it replaced the former line to Ardrossan Winton Pier. Ardrossan Harbour has no facilities at all, but it is only a short walk from there to the ferry terminal for the ferries to the Isle of Arran.

Running south from Kilwinning, the main line to Ayr continues through Irvine and soon reaches Troon, where there was once an avoiding line between Barrasie and Lochgreen. This was closed and the track lifted in 1982, but it was on this line that the original Troon station was situated before the existing station was built and opened in 1892, the old station closing on the same day. South of Troon, the line serves Prestwick Airport and Prestwick Town before passing through the now quiet and nearly empty Falkland Yard and continuing on to Newton-on-Ayr. Falkland Yard was the centre of operations for the numerous coal trains that used to run, but, with the demise of coal traffic, the yard is now almost deserted. The former Ayr Motive Power Depot was also closed when the coal traffic ceased. The junction for the line to Mauchline is still in use but sees very little traffic compared with just a few years earlier. After passing the former depot, the line soon crosses the River Ayr and arrives at Ayr Station, which has two through platforms for services going to Girvan and Stranraer, and two bay platforms that are used by the majority of services that run between Ayr and Glasgow Central. When the Ayr line was electrified, it was Class 318 EMUs that operated the services from 1986 until 2001, when new Class 334 Juniper EMUs, built by Alstom in Birmingham, were introduced onto the Ayr line services. The 334s then worked the line until late 2010, when they started to be replaced by new Siemens Class 380s, which are still working the Ayr line services. The former station hotel closed, and without the necessary maintenance and repairs, it fell into a dangerous condition. As a result, it has been encased within supports and totally sheeted over to ensure the safety of people using the station and adjacent roads.

66715 passes Paisley Gilmour Street on 9 June 2003 with a GBRf Hunterston to Mossend MGR coal trial, which would then go to Longannet power station the following day. The four wagons were ex-Foster Yeoman stone hoppers, as GBRf had no four-wheeled bottom discharge wagons, and its bogie hoppers were not allowed to cross the Forth Bridge loaded because of axle weight issues.

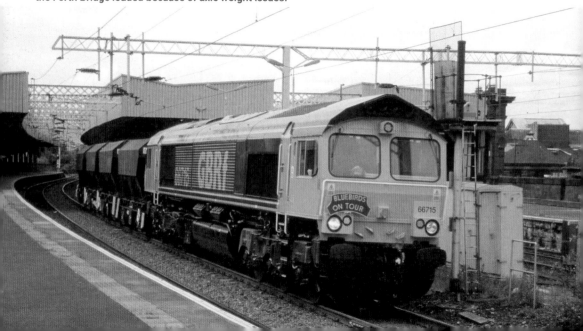

303021 approaches Paisley Gilmour Street with a Gourock to Glasgow Central service on 3 April 2001. 303021 was one of only three sets of the Class 303s that had received the Strathclyde Passenger Transport (SPT) carmine and cream livery.

334012 arrives at Paisley Gilmour Street on 10 December 2002 with the 13.17 from Glasgow Central to Gourock.

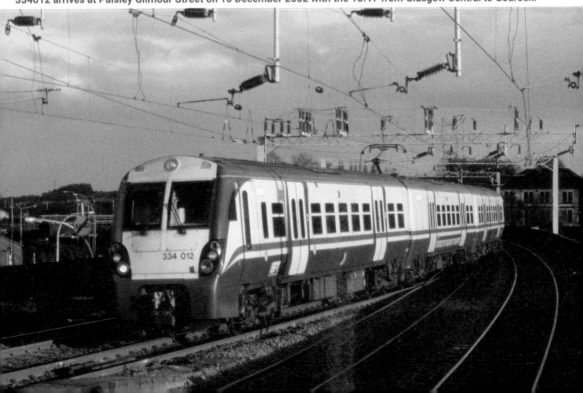

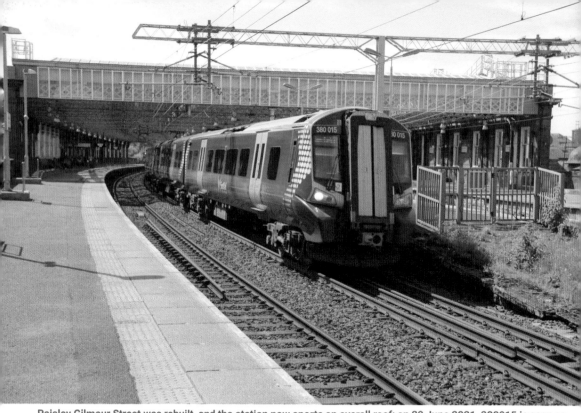

Paisley Gilmour Street was rebuilt, and the station now sports an overall roof; on 29 June 2021, 380015 is seen as it departs with the 14.53 from Largs to Glasgow Central.

66739 approaches Paisley Gilmour Street on 29 June 2021 with the 06.06 Doncaster iPort to Elderslie intermodal; in the distance, 380104 can be seen as it heads for Glasgow Central with the 15.06 from Ayr.

380010 is about to depart from Port Glasgow on 21 June 2021 with the 09.55 Glasgow Central to Gourock. Port Glasgow still retains several of its original features, such as its canopies and waiting areas, but would really benefit from a fresh coat of paint!

385042 departs from Gourock on 18 June 2021 with the 12.08 to Glasgow Central. Class 385s are now making frequent appearances on the Gourock services, as the reduced levels of services on all lines following the COVID-19 pandemic have resulted in a number of spare units.

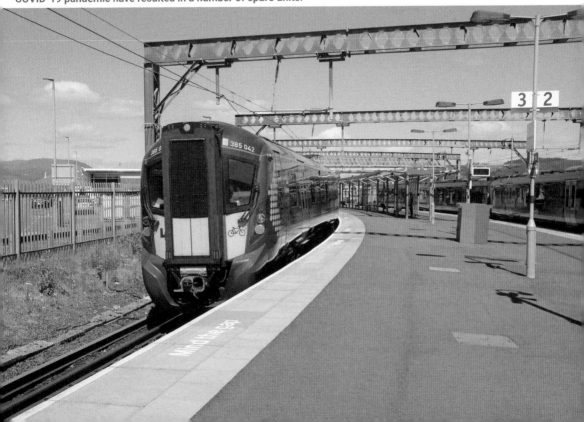

385041 and 380105 are stabled at Platforms 2 and 3 at Gourock on 18 June 2021. Later, they will be called into working peak hour services to and from Glasgow Central.

The interior view of the booking office and ornamental roof at Wemyss Bay station on 18 June 2021. Wemyss Bay is the terminus of the line and has an hourly service to and from Glasgow Central, with extra services at peak times. The station complex also contains the Caledonian MacBrayne Ferry Terminal, with ferry services to Rothesey on the Isle of Bute. This station was designed by James Miller for the Caledonian Railway, replacing an earlier structure, and because of its architecture and the ironwork in its roof, it is a Category A listed building.

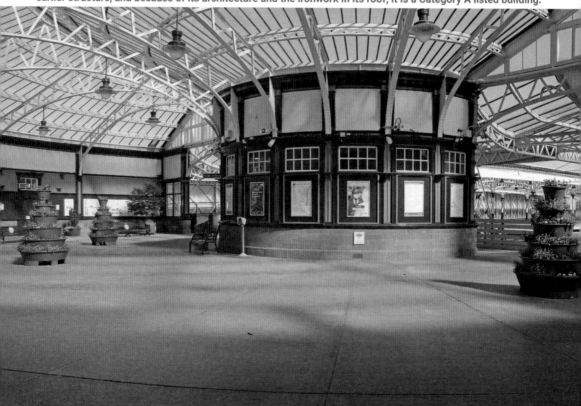

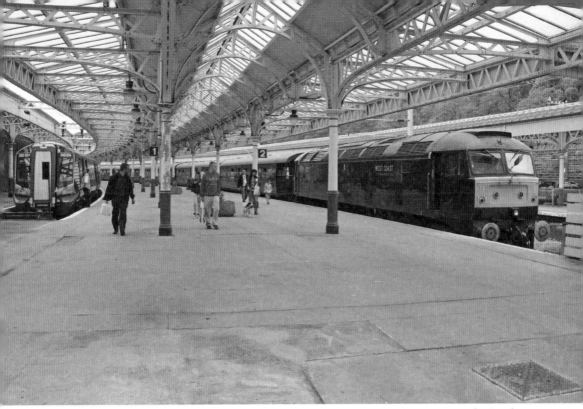

380014 and 57001 with the Royal Scotsman are at Wemyss Bay on 12 June 2011. Passengers on the Royal Scotsman's three-night western tour travel to Bute and back as part of their travel experience.

Just over ten years later, and this time it is 380019 that is stabled at Wemyss Bay alongside 66746 on the Royal Scotsman stock on 1 August 2021.

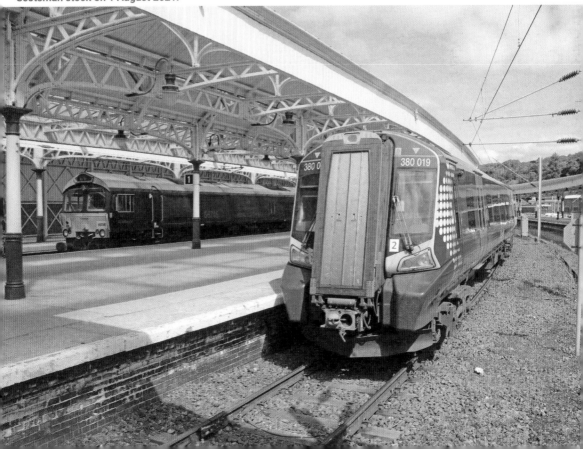

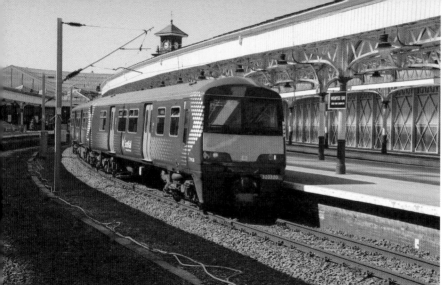

The Class 320 EMUs are having a refresh at Brodies at Kilmarnock, which also involves a repaint. 320320 is seen at Wemyss Bay in ex-works condition on 18 June 2021, before working the 09.57 ScotRail service to Glasgow Central.

380116 arrives at Kilwinning on 4 June 2021 with the 09.34 from Glasgow Central to Ayr. Kilwinning is the junction for the services to Ardrossan Harbour and Largs.

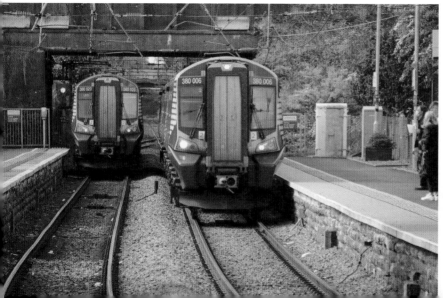

380020 on the 09.48 from Glasgow Central to Largs passes 380006 on the 09.53 from Largs to Glasgow Central at Kilwinning on 4 June 2021.

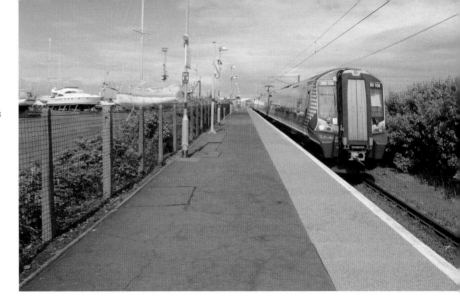

380108 waits at Ardrossan Harbour on 4 June 2021, before working the 11.36 to Glasgow Central. Ardrossan Harbour station has no facilities at all, but the services connect with the ferry to and from the Isle of Arran.

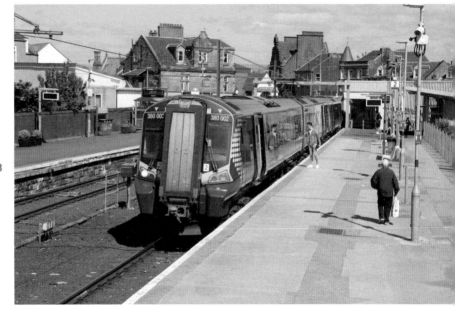

380002 waits at the terminus at Largs on 18 June 2021, before departing with the 10.53 to Glasgow Central.

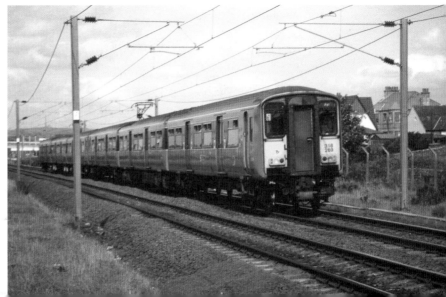

When the line to Ayr was electrified, it was Class 318s that were introduced to work the services. The 318s were painted in the then-orange and brown Strathclyde Passenger Transport (SPT) colours, and, when built, they had corridor connections at the ends of each unit. On 16 August 1997, 318269 and 318265 approach Prestwick Town with the 13.15 service from Glasgow Central to Ayr.

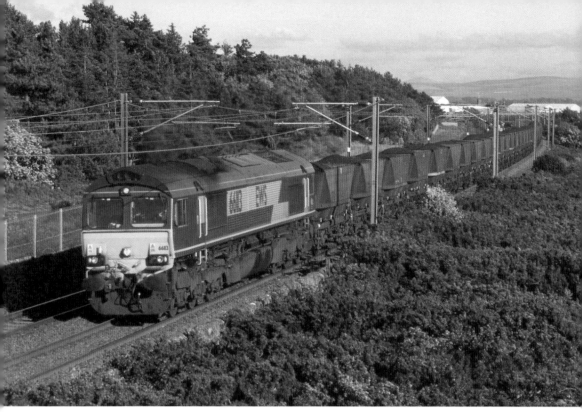

66113 passes Lochgreen, Troon, on 4 June 2004 with a loaded MGR from Falkland Yard to Drax power station, the coal at that time being carried in a series of four-wheeled hopper wagons.

By the time this photograph was taken on 22 February 2010, the four-wheeled wagons had virtually disappeared, and companies like Freightliner were now involved in moving coal in large capacity bogie wagons. 66561 passes Lochgreen, Troon, with a loaded MGR from Killoch to Drax power station.

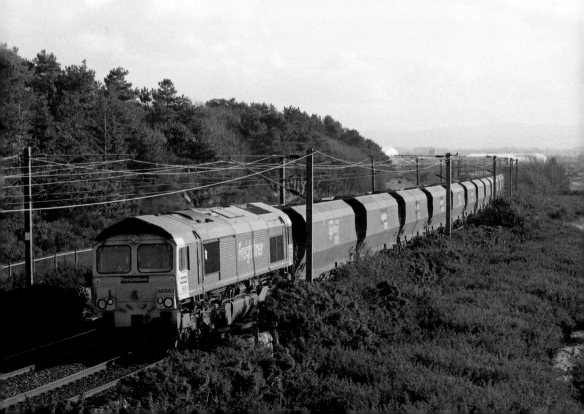

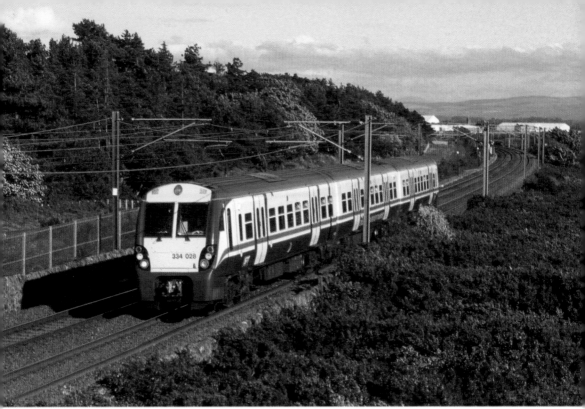

The Class 334 EMUs entered service with SPT in 2001 after several teething problems had been rectified. These smart-looking EMUs were built by Alstom, and on 4 June 2004, 334028 speeds past Lochgreen with the 18.43 from Ayr to Glasgow Central.

At the beginning of this century, Falkland Yard at Ayr was a very busy place. Large numbers of empty coal trains left the yard to be loaded at various sites and were then despatched to power stations in both Scotland and England. On 14 February 1999, 56003 is departing from Falkland Yard with an empty MGR to Hunterston, which, when loaded, it would then take to Longannet power station in Fife.

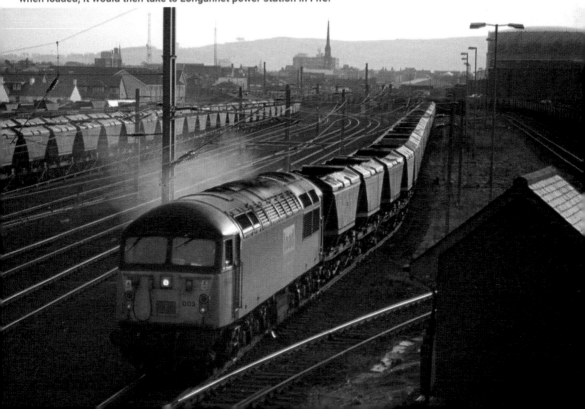

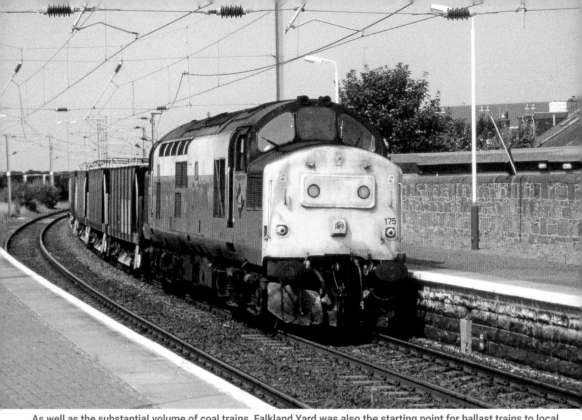

As well as the substantial volume of coal trains, Falkland Yard was also the starting point for ballast trains to local lines. On 8 August 1997, 37175 has just exited the yard and is running slowly through Newton-on-Ayr station with a loaded ballast train for a worksite on the line to Killoch.

SPT changed its colours for trains from orange and brown to carmine and cream. Wearing its new livery, 318256 arrives at Newton-on-Ayr on 30 March 2003 with the 16.00 from Glasgow Central to Ayr.

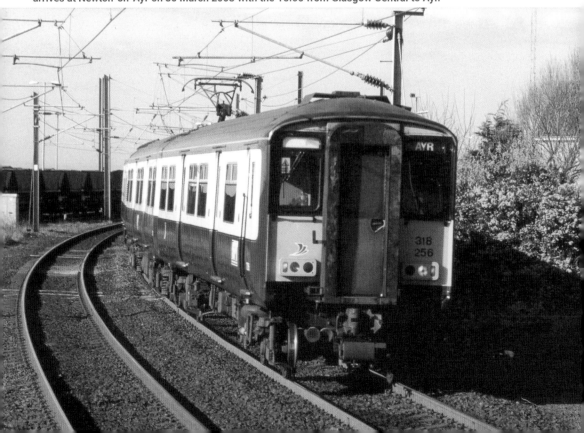

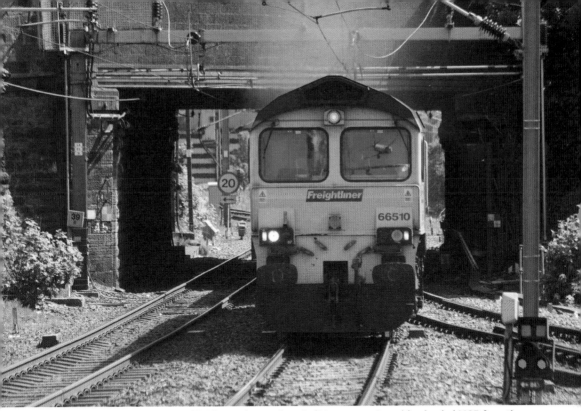

66510 bursts out from under the road bridge at the south end of Newton-on-Ayr with a loaded MGR from the Chalmerston opencast site for Longannet power station on 10 June 2010.

37702, 37698 and 66021 rest between duties at the motive power depot at Ayr on 15 July 2000.

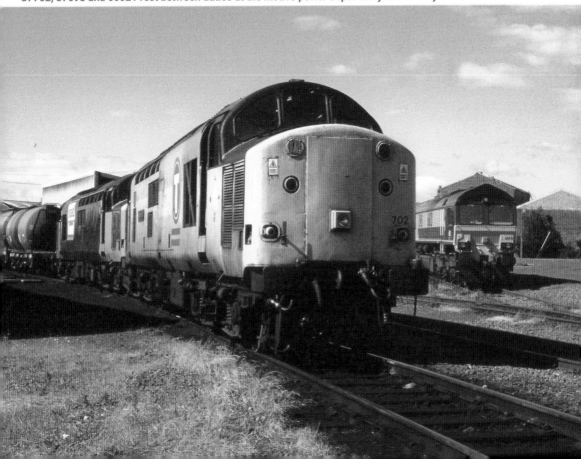

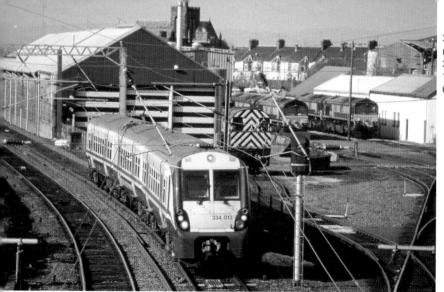

334013 runs past Ayr motive power depot on 30 March 2003 with the 15.00 from Glasgow Central to Ayr.

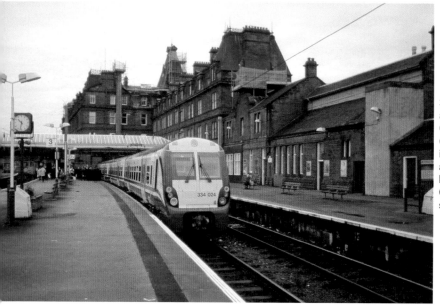

334024 was used on a media special from Glasgow Central to Ayr on 6 December 2002, and it is seen here shortly after arriving at Ayr. The large building is the former G&SWR hotel, which was still in use at that time.

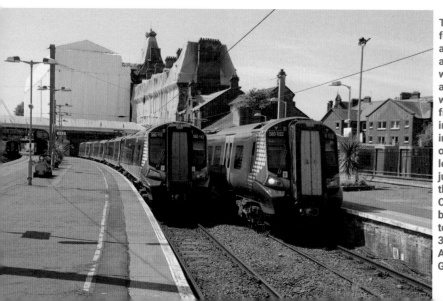

The former railway hotel fell into disrepair and a dangerous condition, and with foreign owners who would not do anything, the building was encapsulated into a frame and sheeted over into the condition seen in this photograph taken on 2 June 2021. From left to right: 380017 has just arrived at Ayr with the 11.04 from Glasgow Central; 380113 is waiting before working the 12.36 to Glasgow Central; and 380022 is departing from Ayr with the 12.06 to Glasgow Central.

Chapter 4
Freight traffic around Ayr

This chapter is not about the small amount of freight traffic that exists at this moment in time, rather it is a look back to when the coal trains were running in large numbers on a daily basis and Falkland Yard was full of wagons and trains, either loaded and about to start what could be a long journey to a power station or an empty one about to set out to be loaded at one of the several coal-loading sites. My frequent visits to Ayrshire gave me a lot of opportunities to record some of the many coal workings, and as this traffic ceased to exist with the collapse of Scottish Coal and the closure of so many former coal-fired power stations, this is a look back at two lines in particular, those to Killoch and Chalmerston.

The photographs in this chapter cover the period from when coal was loaded into MGR trains using four-wheeled hopper wagons. These wagons were gradually phased out and replaced by fleets of bogie coal hoppers, which increased capacity and enabled empty trains to run at increased speeds. The motive power used on Ayrshire coal workings varied from pairs of Class 37s to Class 56s and Class 60s, with the most noticeable change being the introduction, initially by the English, Welsh and Scottish Railway (EWS), but quickly followed by other companies, of the Class 66, a General Motors locomotive built in Canada at London, Ontario. As the new locomotives were introduced, many of the older classes were withdrawn. This chapter will cover a timeframe of 1997 to 2015, as these years were to be a period of great change.

It was once said that Ayrshire was a county that was built on coal. At one time, there was a thriving deep coal mine industry, but, after the ill-fated miners' strike, the deep mines were closed and replaced by numerous opencast mines. This applied to the area around the Chalmerston loading point. Chalmerston was situated just to the north of Dalmellington, which had been served by rail since the arrival of the Ayr and Dalmellington Railway, which had opened in stages up until 1856. At one time, the ironworks and its associated ironstone and coal mining employed more than 2,000 men, and this was the main source of traffic and revenue for the railway. The ironworks closed during a strike in 1921, and from that time the line endured a steady decline in the amount of traffic it carried. The passenger service between Ayr and Dalmellington was withdrawn in April 1964, and it was latterly only the opencast coal from Chalmerston that had kept the line open. The final mile to Chalmerston was a new build, taking the line into the mining complex further east and at a slightly higher elevation than the tracks of the line that ran to Dalmellington. The track of the former line to Dalmellington was lifted from the point where the lines diverged. When Scottish Coal went out of business in 2015, traffic on the line ceased, and although the tracks are still in situ, the line is now heavily overgrown in places, and with Dalrymple Viaduct – the line's major structure – requiring some major repairs, it seems unlikely that any rail traffic will ever return.

The line to Killoch leaves the Ayr to Mauchline line at Annbank Junction. This was the old line to Cronberry, but that line had been closed in the early 1950s, and the deviation to Killoch was built to serve a new colliery that opened at Killoch in 1960. The new line left the trackbed of the old Cronberry line at Drongan. However, this new mine had a short working life, and it was closed in 1987, as a result of flooding caused by the miners' strike. Killoch also had a washery and continued to wash and grade coal, as well as despatching trainloads of coal slurry to Methil power station in Fife. It developed another new lease of life when it became a coal-loading point for locally mined opencast coal.

Plans now exist to build an energy park at Killoch, which will incinerate thousands of tonnes of household waste instead of sending it to landfill sites. In the plans that have been outlined, it was stated that most of the domestic rubbish would be brought in by rail, so it could well be that the Killoch line has a long-term future that has nothing to do with coal. In anticipation that this will happen, there have been a series of upgrades to the track and repairs to the infrastructure, so that, if the plans do come to fruition, the line will be ready to handle the traffic that could run from several sites across Scotland.

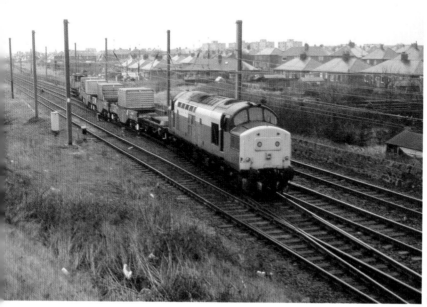

37211 is crossing over to enter Falkland Yard on 2 April 1997 with four flask wagons, complete with a brake van, from Hunterston. The train was recessed in Falkland Yard before continuing its journey south to Sellafield.

37513 and 37248 are a colourful combination in their Loadhaul and Mainline Blue liveries as they pull out of Falkland Yard on 7 July 1997 with a train for Tyne Yard.

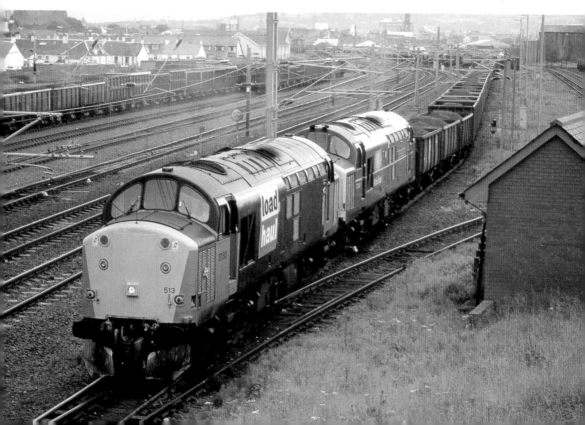

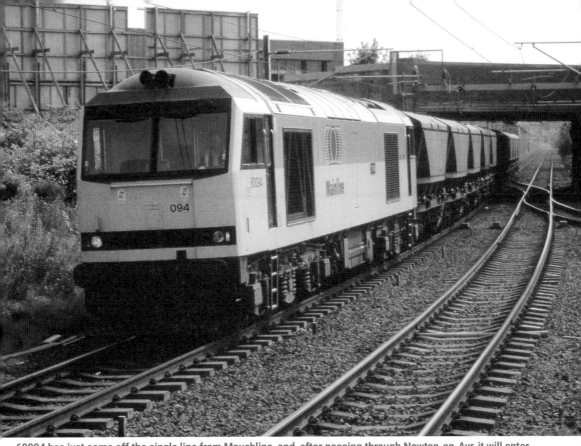

60094 has just come off the single line from Mauchline, and, after passing through Newton-on-Ayr, it will enter Falkland Yard with a train of coal from Knockshinnoch on 8 August 1997.

56117 is captured on 8 August 1998 as it passes Heathfield on the outskirts of Ayr with a loaded MGR from Falkland Yard to Cottam power station.

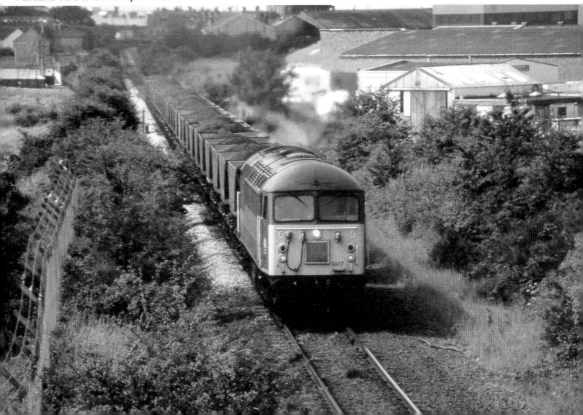

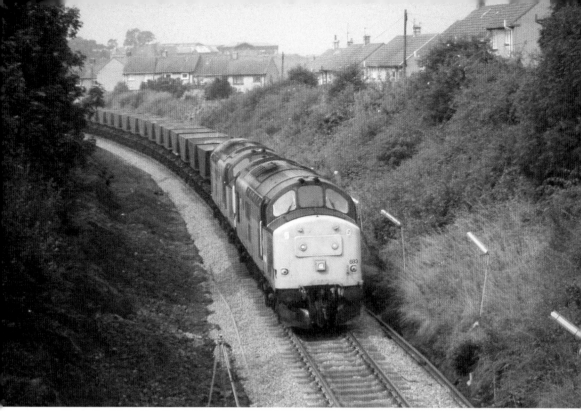

37683 and 37675 are approaching Annbank Junction with an empty MGR from Falkland Yard for loading at Killoch on 12 August 1997.

On 23 October 1998, 60078 pulls away from a signal stop as it leaves the Killoch line and joins the line from Mauchline, which will take it to Falkland Yard with its loaded MGR destined for Drax power station.

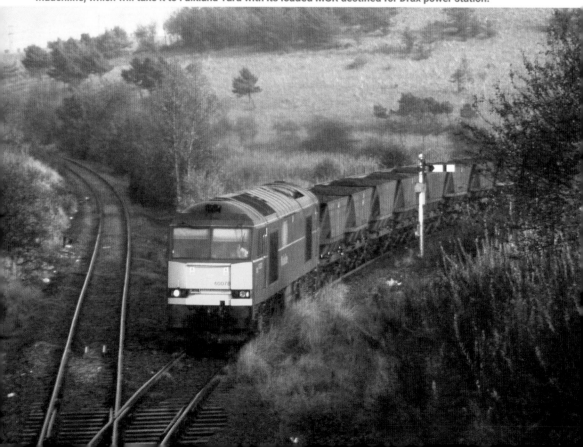

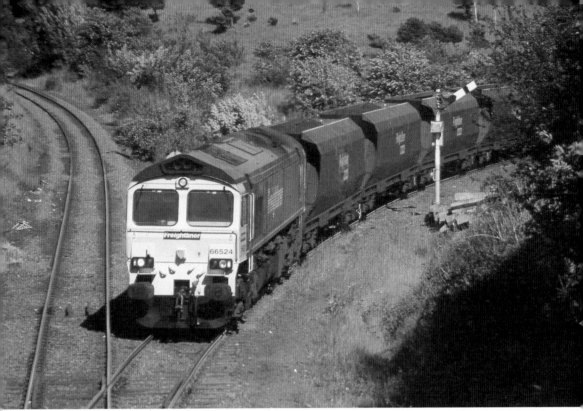

A Freightliner loaded MGR from Killoch to Drax leaves the line from Killoch at Annbank junction at the start of its long journey south behind 66524 on 4 June 2004.

56058 crosses Enterkin Viaduct over the River Ayr on 14 August 1997 with the empty coal slurry wagons from Methil power station returning to Killoch to be loaded. Methil power station burned coal slurry, a by-product of washing coal at Killoch.

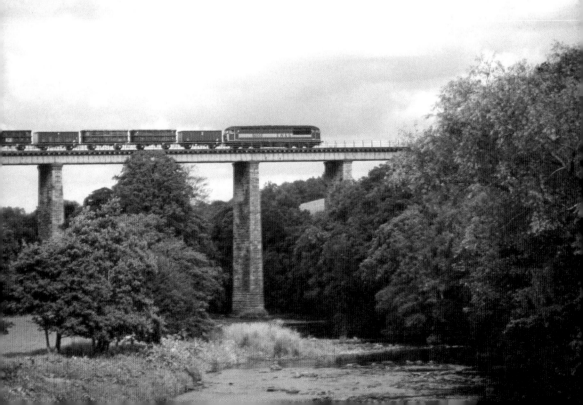

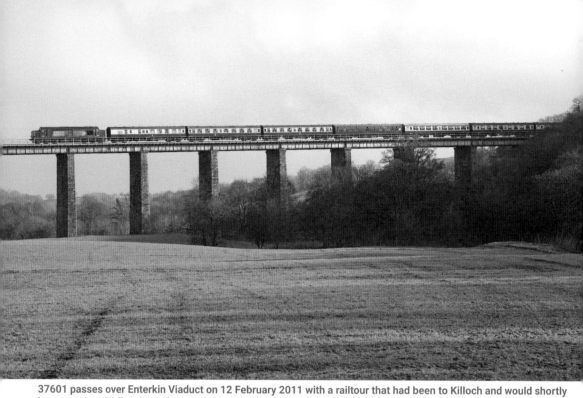

37601 passes over Enterkin Viaduct on 12 February 2011 with a railtour that had been to Killoch and would shortly be traversing the line to Chalmerston as far as Dunaskin.

With its train of bogie hoppers, National Power's 59206 has just departed from Killoch on 6 May 1998 with a coal trial from Killoch to Falkland Yard.

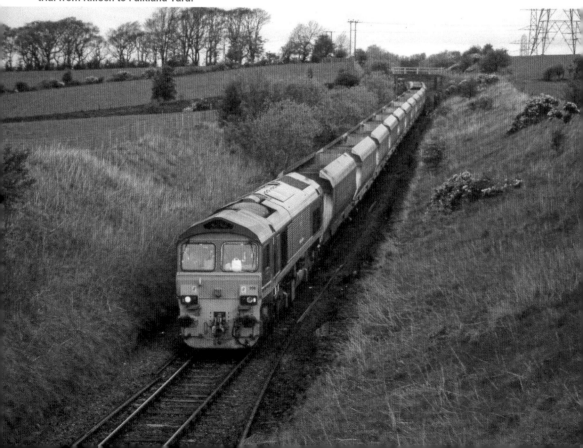

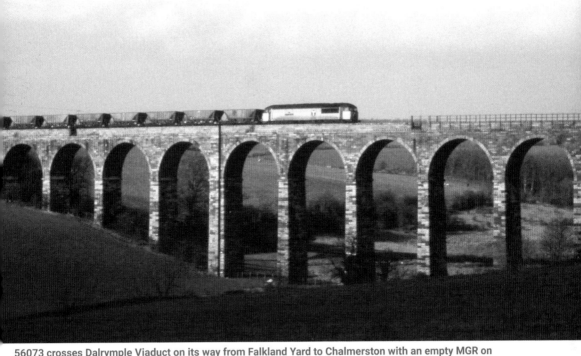

56073 crosses Dalrymple Viaduct on its way from Falkland Yard to Chalmerston with an empty MGR on 13 February 1998.

37607 and 37601 cross Dalrymple Viaduct on 12 February 2011 with the railtour that had been to Killoch and was now going up the Chalmerston line. It was not allowed to go all the way to Chalmerston and had to turn round at Dunaskin, just over a mile short of Chalmerston.

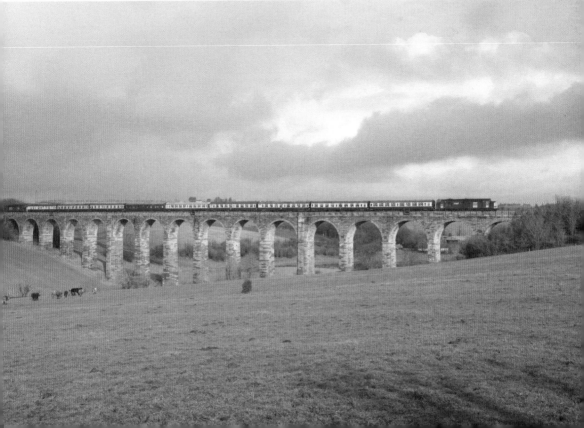

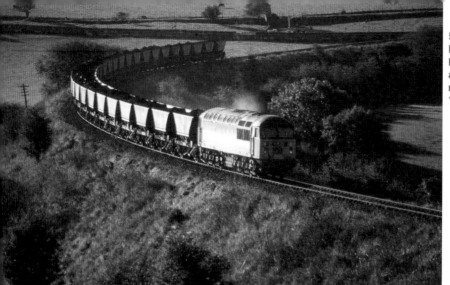

56057 brings a loaded MGR from Chalmerston to Falkland Yard downgrade at Hollybush, glinting nicely in the sunshine on 13 October 1997.

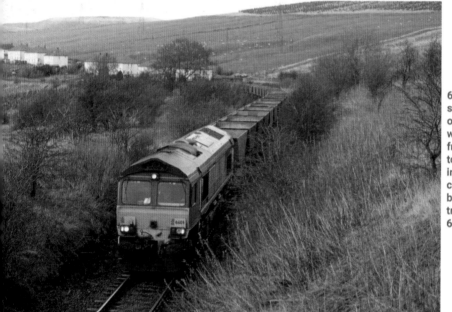

66109 has just passed the small village of Polnessan on 1 February 2002 with an empty MGR from Falkland Yard to Chalmerston. An indication of how this line climbed up the valley can be seen by looking at the tracks at Polnessan that 66109 just negotiated.

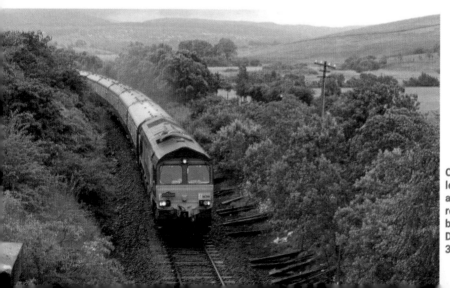

On 14 July 2001, 66246 leaves Dunaskin with a Pathfinder Railtour returning to Ayr having been hauled up to Dunaskin by 37707 and 37886.

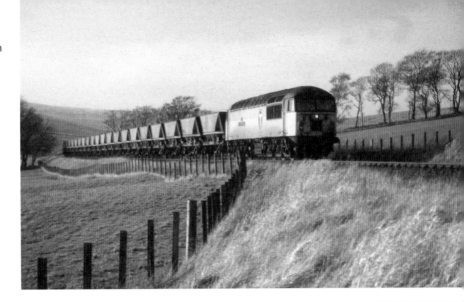

56073 climbs the last mile to Chalmerston on 13 February 1998 with an empty MGR from Falkland Yard.

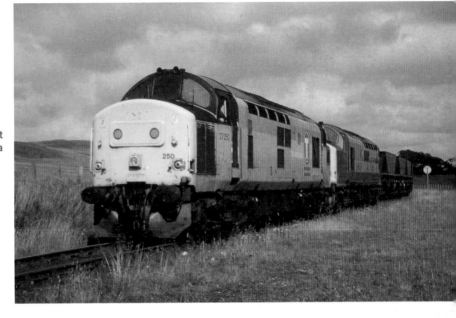

37250 and 37684 depart from Chalmerston with a loaded MGR to Falkland Yard on 5 August 1998.

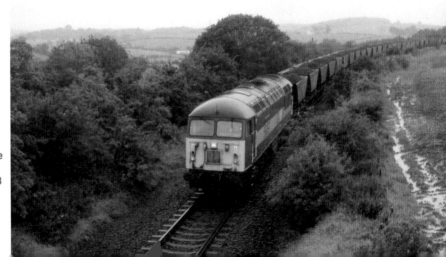

On an exceedingly wet day in Ayrshire, 56057 grinds uphill near the site of the former Tarbolton station on 7 August 1998 with a loaded coal train from Falkland Yard to Blackburn.

Chapter 5
Ayr to Stranraer

When the Ayr and Dalmellington Railway opened in 1854, as a result of the importance of the iron and coal traffic, the line to Dalmellington was viewed as the 'main line', and the line that ran south and terminated in Maybole was classed as the secondary line. At that time, Dalrymple Junction was known as 'Maybole Junction', and the line to Maybole terminated about 400 yards to the north of the existing Maybole station. In 1860, the line was extended through Maybole as far as Girvan and terminated adjacent to Girvan Harbour. Seventeen years later, in 1877, the Girvan and Portpatrick Railway was opened, worked at first by the G&SWR, which then absorbed it in 1892.

The line from Dumfries to Stranraer, the 'Port Road' as it was known, had been built in two stages: the Dumfries to Castle Douglas railway reaching Castle Douglas in 1859, where it met the Portpatrick Railway's line from Stranraer to Castle Douglas, which opened in 1861. The line from Girvan joined the line from Castle Douglas at Challoch Junction, between Dunragit and Glenluce. When the line opened, and there were rail connections with the ferry to Larne, a contract to carry mail was made with Royal Mail, which was a source of much needed income.

The line south from Ayr now has only three stations still open between Ayr and Stranraer, with the stations at Pinmore, Pinwherry, Glenwhilly and New Luce having closed in the mid-1960s. The first station south of Ayr is Maybole, a town that used to have many industries, all of which are now closed. It used to be a double-track railway between Ayr and Girvan, and Maybole had two platforms and a signal box. In the 1960s, the line was singled between Dalrymple Junction and Girvan with one passing loop situated at Kilkerran, between Maybole and Girvan.

Girvan Station is unique in Scotland as it is the only one in to be built in Art Deco style. The original station building at Girvan had been destroyed in a fire in 1946, and the replacement building was not completed until 1951. Thanks to its architectural style, it is now a Category B listed building. The only item that was saved from the original station was the station clock, which, after restoration, was incorporated into the new station in 1952.

The only station still open between Girvan and Stranraer serves the village of Barrhill and its surrounding area. Barrhill has a passing loop and is also the only place on the line where the token machines are not in a signal box but are instead situated in the station building. The very small wooden signal box was brought to Barrhill from Portpatrick, after the Stranraer to Portpatrick line closed in February 1950. The line between Girvan and Stranraer is also one of the last lines on the UK national network to still use tokens and staff. In the days of steam, tablets could be exchanged between a fireman and the signalman without the train having to stop, but on the Girvan to Stranraer line, tablets have to be either issued or exchanged at Girvan, Barrhill, Glenwhilly and Dunragit, and at each place, the current ScotRail Class 156 DMUs have to stop while the driver exchanges the token, which is another reason why journey times now take as long as they do.

Stranraer station was once called Stranraer Harbour, and the ferry terminal was on the west side of the road that runs parallel with the line from where the jetty starts to go out into Loch Ryan. The station was refurbished in 1984 and had further major repairs and alterations in 2014. There had been another station in Stranraer, appropriately called Stranraer Town, but this station was closed in March 1966. The Stranraer station site was ideal when the ferries sailed from there, but in November 2011, when the ferries relocated from Stranraer to Cairnryan, several miles closer to the mouth of Loch Ryan, which helped to

reduce the journey time to sail from Cairnryan to Belfast, it was no longer ideal for passengers from the town and the surrounding area. Stenna Line had changed from sailing to Larne to sailing to Belfast in 1995. As Stranraer station is now not conveniently situated, it had been proposed to build a new terminus close to the former Stranraer Town station. Money for this project was supposed to be ring-fenced, but Dumfries and Galloway Council went ahead and used the money elsewhere, so the former harbour station is still in use.

Freight traffic to Stranraer remained, with a daily freight service that lasted until the end of the Speedlink services in 1993. The last freight service to use the line was a daily steel train from Tees Yard, the steel being trans-shipped at Stranraer and sent to Northern Ireland on the ferry. The Stranraer freight depot remained until 2009 when it was closed completely. The sidings were gradually removed until, by 2017, all the sidings had been lifted and very few traces now remain of the former goods yard and the site of the adjacent engine shed.

South of Girvan has always been a very difficult part of the line to operate, as it has some very severe gradients. From the end of the platform at Girvan, the line climbs at a steady 1 in 54 to Pinmore tunnel, and then after passing through what is a tunnel with tight clearances, it falls at 1 in 69 to Pinwherry. After Pinwherry, another uphill climb commences with just over eight miles at 1 in 67 to the Chirmoorie summit at 690ft above sea level and that is then followed by a descent all the way to the site of the former Challoch Junction, east of Dunragit, at 1 in 56. The G&SWR, and then the London, Midland and Scottish Railway (LMS) after the 1923 grouping, were not able to use modern locomotives as the turntable at Stranraer was only a small 50ft one. A new 60ft turntable was installed just before the onset of World War Two, and this enabled the use of the 'Black 5s' on freights and a few passenger workings. The bulk of the passenger services, however, were worked by Jubilee Class 4-6-0s, and these classes worked the majority of services until the end of steam. After the local services had been operated for several years by DMUs, the line reverted to diesel locomotives hauling rakes of coaches between 1984 and 1987, until, in October 1988, Class 156 Super Sprinter DMUs were introduced onto the Stranraer line. Thirty-three years later, they are still working the trains between Ayr, Girvan and Stranraer. The boat trains between Glasgow and Stranraer and those to and from Euston were the preserve of Class 47 diesels until they were withdrawn in the early 1990s. Passengers using the ferries are now bussed between Cairnryan and the station at Ayr.

156467 arrives at Ayr on 2 June 2021 with the 12.02 from Kilmarnock to Girvan.

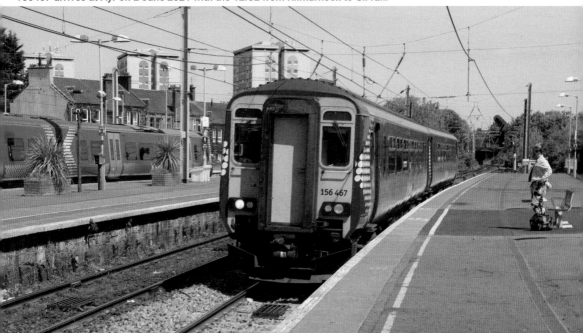

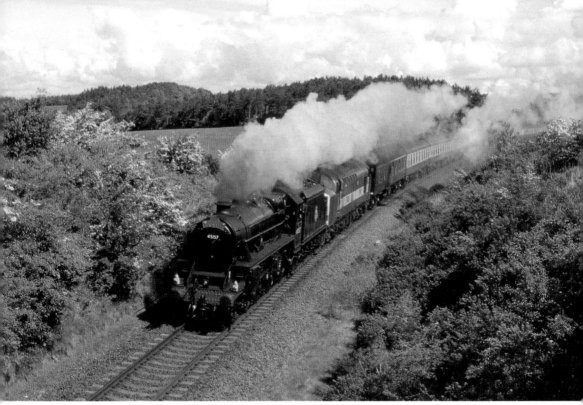

45157 and 37405 pass the site of the former Cassillis station near Minishant, between Dalrymple Junction and Maybole, on 28 May 2000.

156442 arrives at Maybole on 2 June 2021 with the 10.28 to Girvan. Maybole used to be a two-platform station, complete with a signal box on the now-disused platform; before, the line between Girvan and Dalrymple Junction was singled with just one passing loop at Kilkerran.

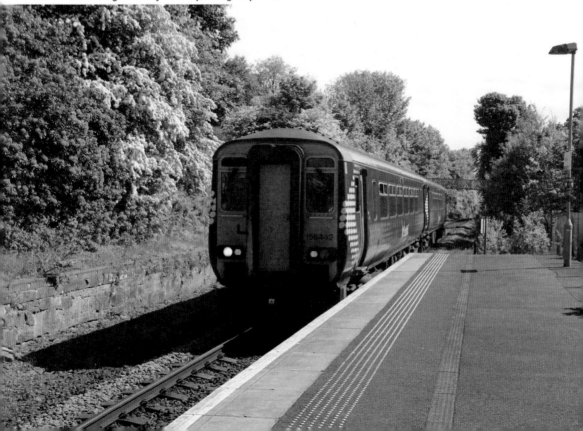

The Class 156s have been working the passenger services for over 30 years, and in that time, they have appeared in a surprising variety of liveries. On 17 August 1997, 156501, in SPT orange, leads 156462 in Regional Railways ivory and blue soon after they had departed from Maybole with a Glasgow Central to Stranraer service.

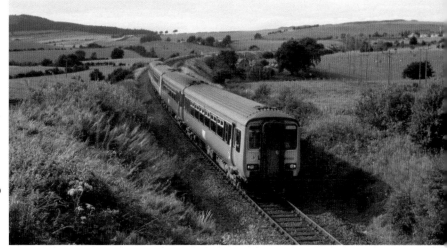

Right: Black 5s 44871 and 45407 are seen south of Maybole with the 'Great Britain III' railtour from Ayr to Stranraer on 10 April 2010.

Below: A Class 156 in SPT carmine and cream is seen between Kilkerran and Maybole with a Stranraer to Glasgow Central service on 19 July 2003. Apart from Maybole and Girvan, the line runs through some very sparsely populated rural country.

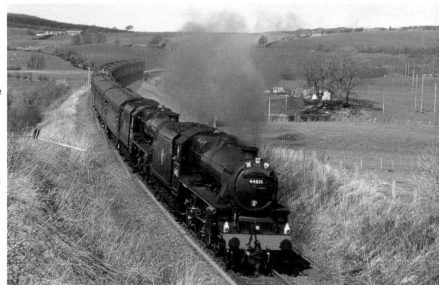

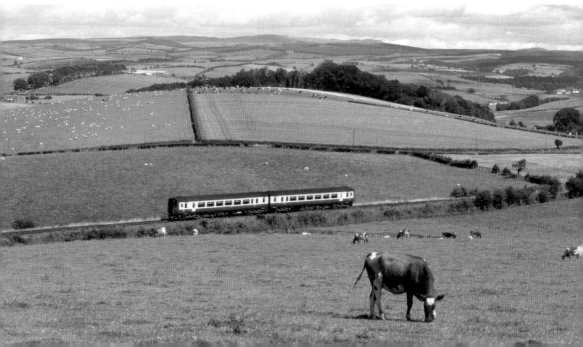

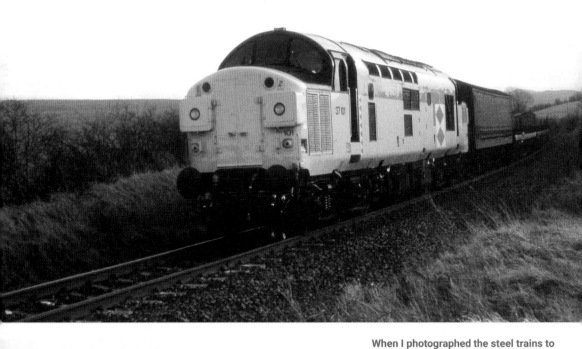

When I photographed the steel trains to Stranraer and the empties returning to Teesside, they did not have that long to last before the steel traffic on the railway was discontinued. On 24 February 1989, in fading light, I photographed an immaculate 37101, in Rail Distribution sub-sector colours, between Kilkerran and Maybole with the empty wagons returning to Tees Yard.

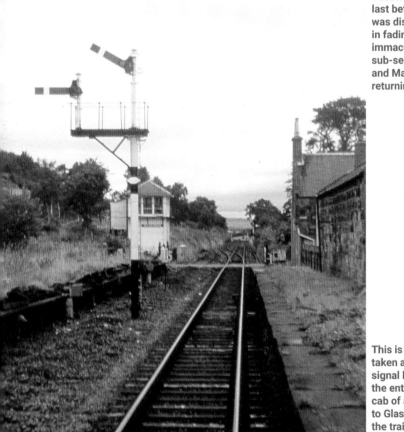

This is the first of three photographs taken at Kilkerran, and it shows the signal box and the signal controlling the entry to the passing loop from the cab of a train travelling from Stranraer to Glasgow Central. The route is set for the train to run straight along the main through line.

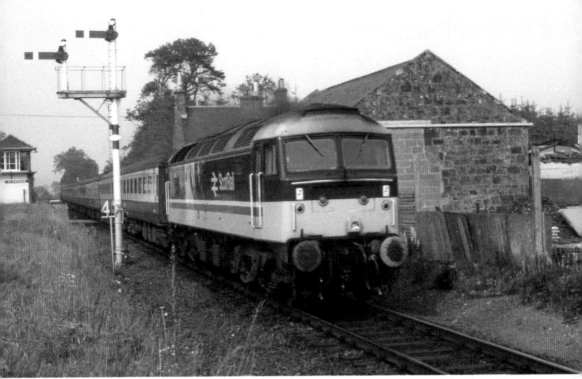

The second photograph from Kilkerran shows 47643 (now preserved by the SRPS at Bo'ness) taking a Glasgow Central to Stranraer service south past Kilkerran on 5 July 1986.

The third photograph is from inside the signal box at Kilkerran as 156511 runs north with the 18.42 Girvan to Kilmarnock ScotRail service on 3 June 2004.

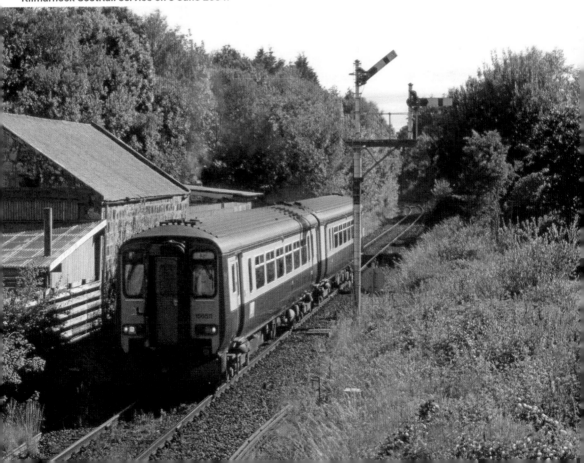

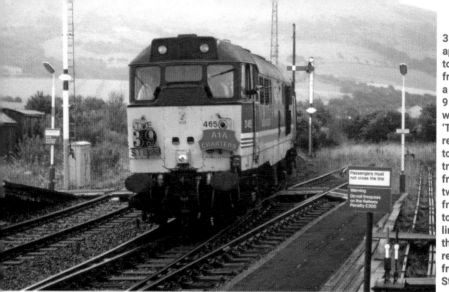

31465 and 31467 approach Girvan and slow to hand over the token from Barrhill at 10.15 on a very misty and damp 9 August 1997. They are working A1A Charters' 'The 39 Steps' railtour returning from Stranraer to Ayr. This tour had travelled up overnight from Stafford, with the two Class 31s working from Preston. After the tour had visited various lines in Central Scotland, the two Class 31s returned the train south from Glasgow Central to Stafford later that day.

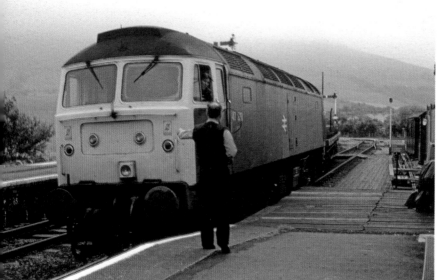

On 12 June 1989, it was 47388 that was taking the steel empty wagons back from Stranraer to Tees Yard, and it approaches Girvan with the driver about to hand over the token from Barrhill to the Girvan signalman.

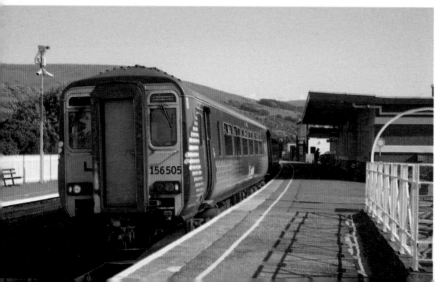

A very clean 156505 in Saltire livery is about to depart from Girvan on 10 June 2010 with the 17.33 to Kilmarnock.

37607 and 37423 are climbing the 1 in 54 gradient from Girvan to Pinmore Tunnel on 4 April 2010 with the UK Railtours' 'The Easter West Highlander' railtour. This tour had started from London on 2 April, with the passengers then staying in hotels in the Dumbarton area. The previous day, it had run to Oban, and the following day it was to return to London.

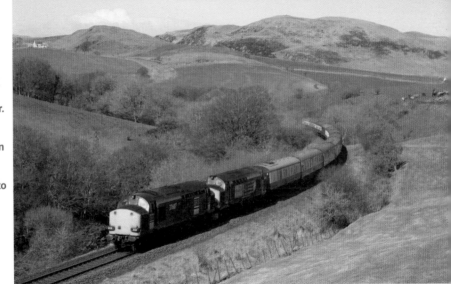

On 9 June 2007, a railtour ran from Darlington to Stranraer, jointly organised by the SRPS and North-Eastern Railtours, using preserved Class 40 40145. With DRS' Class 47 47501 on the rear, the Class 40 is seen as it toiled up the last mile to the summit of the climb from Girvan at Pinmore Tunnel.

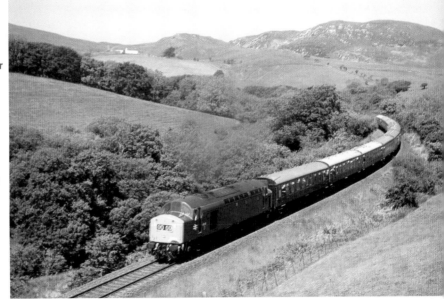

Black 5s 44872 and 45407 are attacking the steep climb up from Girvan to Pinmore Tunnel on 10 April 2010 with the Stranraer leg of the 'Great Britain III' railtour.

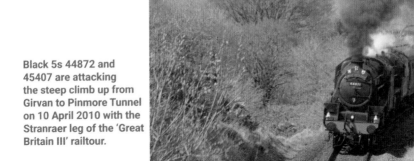

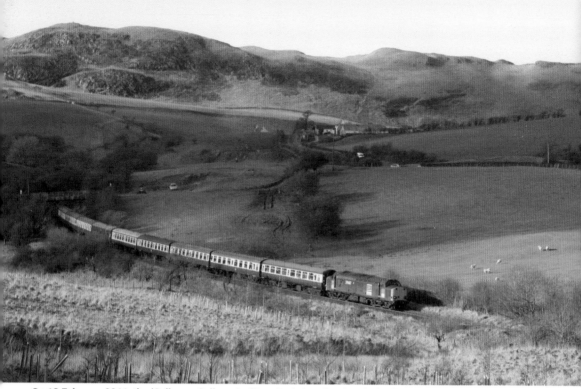

On 12 February 2011, the 'Galloway Galloper' railtour had already taken in the freight-only lines from Ayr to Killoch and Chalmerston (illustrated in Chapter 4), and the final leg of the railtour was from Ayr to Stranraer. With 37607 leading and 37601 pushing on the rear, the train nears the top of the climb from Girvan to Pinmore Tunnel.

Owing to weight restrictions, Class 66s were supposed to be banned from working to Stranraer, but on 20 April 2003, the Paisley to Stranraer part of Hertfordshire Railtours' 'The Easter West Highlander' railtour ran to Stranraer, top and tailed by 66102 and 66211. With a departure from Stranraer at 18.15, it was only minutes before sunset when 66211 crossed Pinmore Viaduct returning the train to Paisley.

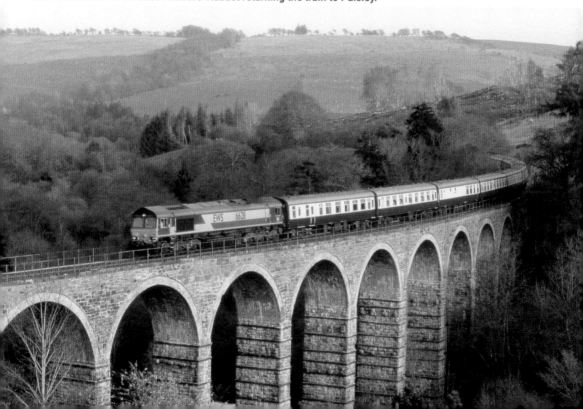

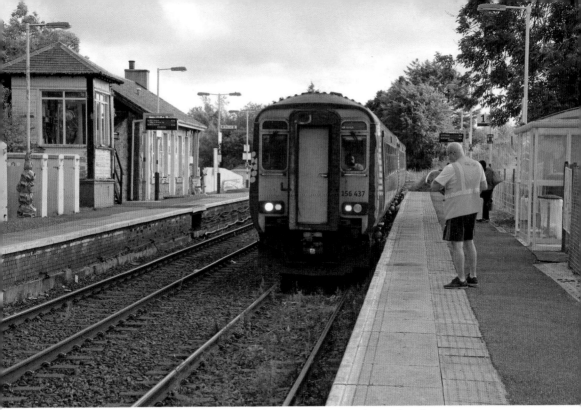

156437 enters the station at Barrhill, where the signalman is waiting to exchange the tokens, on 11 September 2021 with the 15.00 from Stranraer to Kilmarnock.

On 4 April 2010, UK Railtours' 'The Easter West Highlander' ran to Stranraer and was double-headed by 37607 and 37423 as far as Dunragit. Here, 37607 was detached, ran forward then back into the passing loop, and 37423 took the train the last few miles to Stranraer. At Stranraer, the signal box was specially opened, and after 37423 had arrived there, 37607 then ran light engine to Stranraer. This image shows 37607 running past the signal box at Dunragit after uncoupling from 37423.

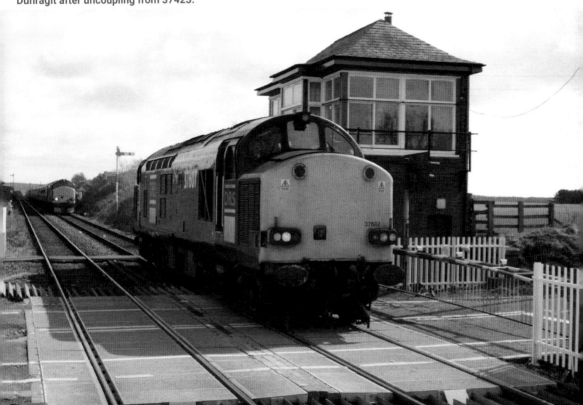

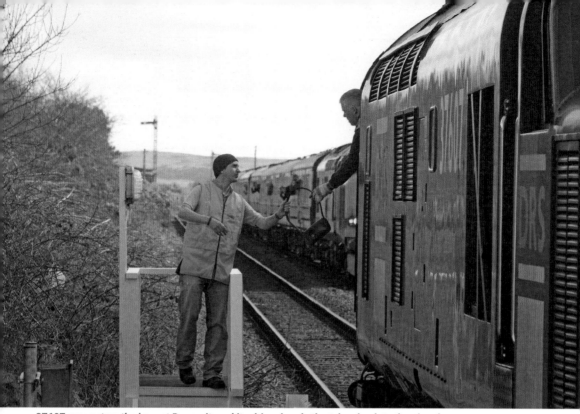

37607 now enters the loop at Dunragit, and its driver hands the token back to the signalman.

Shortly afterwards, 37423 gets the signal to proceed to Stranraer, and its driver is about to collect the Dunragit to Stranraer token from the Dunragit signalman.

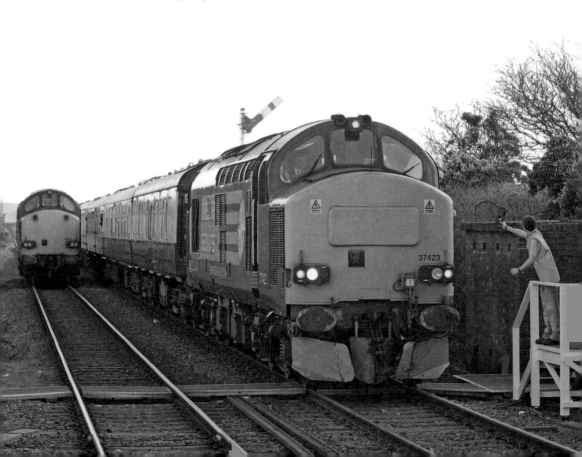

The driver of 156437 has just collected the token after stopping at Dunragit signal box, and the train is now starting on the last part of its journey to Stranraer with the 13.03 from Kilmarnock on 11 September 2021.

37423 is seen at Stranraer after being released from the front of the railtour by 37607 drawing the stock back out of the station on 4 April 2010.

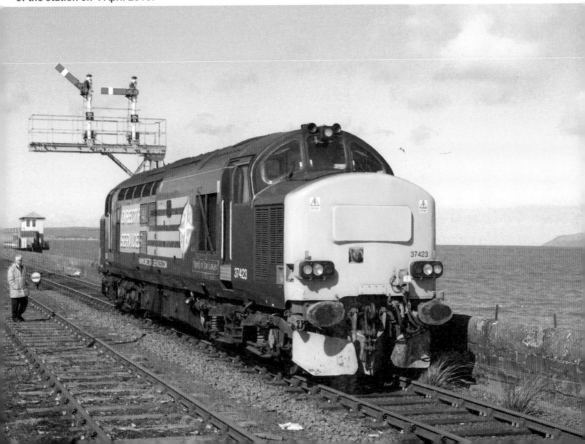

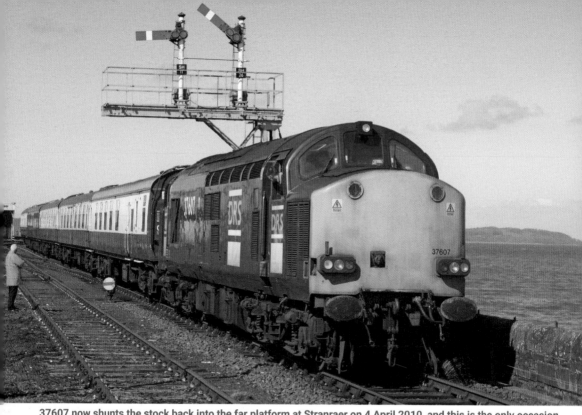

37607 now shunts the stock back into the far platform at Stranraer on 4 April 2010, and this is the only occasion that I have photographed a train entering that platform with that signal cleared for it to do so.

66211 sits with the Hertfordshire Railtours' 'The Easter West Highlander' railtour coaches at Stranraer as it waits for its evening departure to Paisley on 20 April 2003.

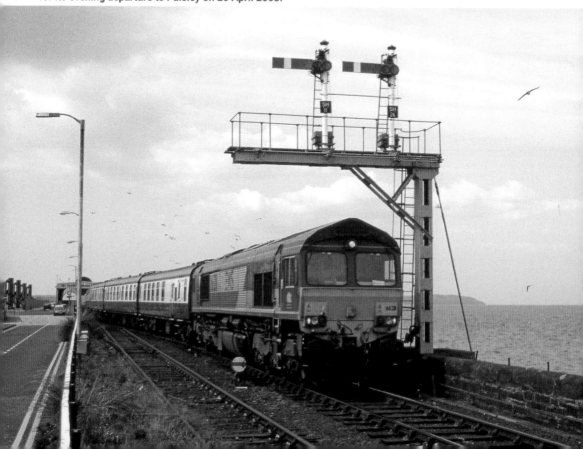

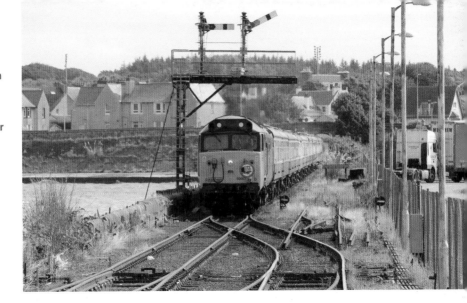

With 50049 on the rear, 50007 arrives at Stranraer on 11 September 2021 on the 04.52 Pathfinder Railtour from Tame Bridge Parkway. This eliminated the need for engines to run round at either Stranraer or Dunragit.

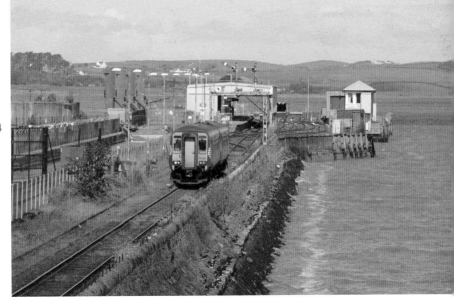

On 22 May 2021, 156434 departs from Stranraer with the 11.06 ScotRail service to Kilmarnock.

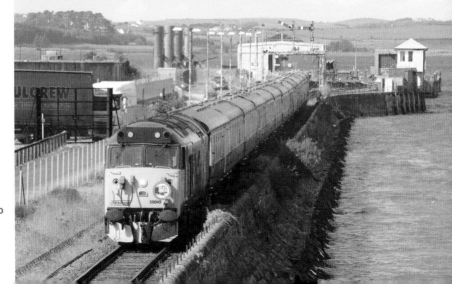

50049 takes the 13.52 return Pathfinder Railtour away from Stranraer on 11 September 2021 at the start of its journey to Birmingham New Street with 50007 now on the rear.

Kilmarnock to Gretna Green

The Glasgow, Dumfries and Carlisle Railway constructed its line from south of Cumnock to Gretna and opened it in stages between 1846 and 1850. It connected near Cumnock with the Glasgow, Paisley, Kilmarnock and Ayr Railway, and once it was open through to Gretna, the two companies amalgamated to form the Glasgow and South Western Railway. The G&SWR wanted to tap into the cross-border traffic that was benefitting the North British Railway through its main line down the east coast and its alliance with the North Eastern Railway and the Caledonian with their English partner the London and North Western Railway (LNWR), as both companies had seen an increase in traffic and this had left the G&SWR isolated in its own area of Scotland. This situation altered when the Midland Railway (MR) reached Carlisle from the south in 1876, and it was not long before the G&SWR and the MR had formed an alliance to run cross-border passenger and goods services. As they could not compete with the timings taken by the Caledonian and the LNWR, the answer was to run trains with vastly superior and more comfortable carriages. Right up to the end of British Railways' days, the Thames-Clyde Express ran daily from Glasgow via Kilmarnock and Dumfries to Carlisle and then over the Settle and Carlisle line to Leeds before heading south via Sheffield to London St Pancras. Nowadays, all the passenger services between Glasgow and Carlisle are worked by Class 156 DMUs.

As the line leaves Kilmarnock, it is already starting the long climb up to Polquap Summit, between Cumnock and New Cumnock. The line soon passes Hurlford, the former junction for the branch line to Darvel and the site of the engine shed that served the Kilmarnock area in the days of steam. The branch had opened in 1848 as far as Galston but did not reach Darvel until 1896. In 1905, the Caledonian Railway built a line from Strathaven to Darvel, and the line then became a through route, but passenger services from Kilmarnock never went further than Darvel, and the projected level of traffic never materialised. The line from Darvel to Strathaven closed in 1939, although the branch to Darvel lasted until 1964.

The main line continues south and, after passing through Mossgiel Tunnel, soon reaches Mauchline where it is joined by the line from Newton-on-Ayr. Mauchline, despite its growing population, no longer has a station as it was closed along with many others along the line on 6 December 1965. South of Mauchline was Brackenhill Junction, where the mile-and-a-half-long branch line to Catrine left the main line; the branch line did not open to traffic until as late as September 1903. As an economic measure, services were initially reduced at the start of World War One and then suspended in 1917, but they were reinstated after the war in 1919. The Catrine branch was for some time worked by a railmotor (a steam railcar), with the service to and from Catrine also serving stations on the line between Mauchline and Ayr. Passenger services to Catrine were withdrawn in 1943 and goods traffic ceased in July 1964, after which all tracks were lifted and Brackenhill signal box closed. The line continues south and soon crosses Ballochmyle Viaduct. This viaduct is the highest viaduct in the UK, the line crossing 169ft above the River Ayr. When it was built in 1848, it also had the longest masonry

arch in the world, and it still is one of the longest. In 1989, it was classed as an A listed structure and because of the number of heavy coal trains then passing over it, it was strengthened in 2010.

The line passes through Auchinleck, where the station was closed in December 1965 but then reopened in May 1984. After Auchinleck, it passes Cumnock, a major coal producing area in the 19th and early 20th centuries. Cumnock was another place where its station closed in 1965, and despite local calls for a station to be built there, so far there has been no sign of that happening. The line continues to climb through Blackfaulds Cutting and shortly afterwards reaches the summit of the line at Polquap, 616ft above sea level. The land around Polquap is moorland and is not nearly as imposing as that of the Caledonian Railway's line at Beattock. After Polquap, the line passes Bank Junction, where a line to the washery and coal loading plant at Knockshinnoch diverged to the south, and it was off that line that the steeply graded branch to the Greenburn opencast site was constructed. The line swings round to the south and approaches New Cumnock, where coal was loaded until 2016 when the coal industry collapsed. New Cumnock's station had also closed on 6 December 1965, but a new station was built, and this was opened on 22 May 1991.

After New Cumnock, the line starts a gentle descent as it runs along the infant River Nith valley to the next station at Kirkconnel, which escaped the cuts of 1965 and has remained open since it was built in 1848. Coal was mined locally, and there were extensive sidings at Kirkconnel for the coal traffic, most of which have now been removed. There were so many heavy coal trains running south on the G&SWR that the line was extensively rebuilt. Millions of pounds were spent upgrading the line with improvements to the track and at the lineside where, because of numerous landslips, many areas had cutting sides and embankments built up and stabilised; the irony being that, just as this work was concluding, coal traffic virtually stopped, with only the odd one running to use up coal stock that was stored at the loading points.

The line continues south through Sanquar, where the station did not open until October 1850; like others, it was closed in December 1965 but then reopened in 1994. South of Sanquar, the line hugs the hillside with some sharp curves in the Mennock Pass before plunging into Drumlanrig Tunnel, which, at 1,395 yards in length, is the third longest railway tunnel in Scotland. The line then reaches Thornhill, where the original station was another that was closed in December 1965. There are plans in existence to build a new station to the north of where the former station was located, which would give easier access for the residents of the country town of Thornhill. The signal box at Thornhill is still in operation.

Dumfries station is a large one, with platforms that can hold trains of up to ten coaches in length. It also has additional services to and from Carlisle, as well as the through ones to and from Glasgow. However, Dumfries is a mere shadow of how it once was when services ran over the Port Road to Stranraer, when there was local freight traffic and a local engine shed. After Dumfries, the line runs eastwards along the flood plain of the Solway Firth and after 15 miles reaches the town of Annan. Goods traffic here lasted until the late 1980s, and after the electrification of the WCML in 1975, the eight miles of track between Annan and Gretna Green was singled as an economy measure. With the ever-increasing number of heavy coal trains, the second line was re-laid and brought back into use in 2008, but, after a further eight years, the coal traffic had virtually ceased. Gretna Green station was also closed in December 1965 but was then reopened with a single platform in September 1993. When the double track to Annan was reinstated, a second platform was built, and this opened in 2008. A mile beyond Gretna Green, the line joins the WCML for the last nine miles to Carlisle.

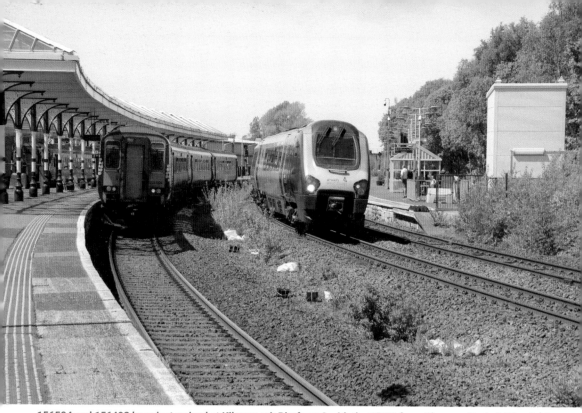

156504 and 156492 have just arrived at Kilmarnock Platform 3 with the 12.53 from Glasgow Central. They had been followed by 221110 on the 12.53 Glasgow Central to Carlisle, which passed through on the centre road on 31 May 2021.

50007 and 50049 power the 13.52 Stranraer to Birmingham New Street railtour south between Hurlford and Mauchline on 11 September 2021, reviving memories of when services between Glasgow and Euston were hauled by pairs of Class 50s, and were diverted over the G&SWR when the WCML was being electrified.

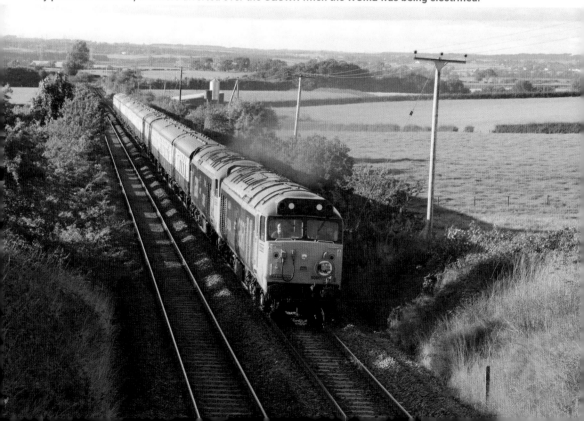

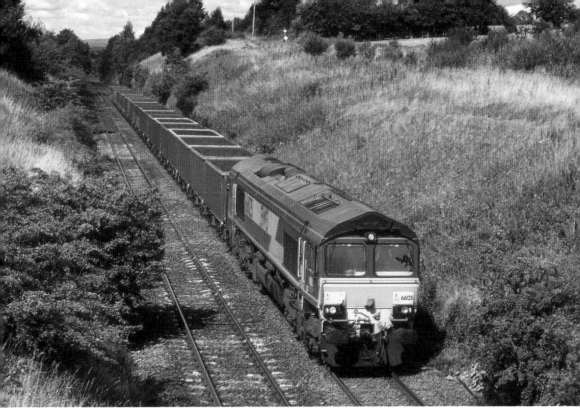

66125 is climbing through Blackfaulds Cutting on 13 August 2009 with the 10.14 Carlisle Yard to New Cumnock. The coal was destined for the cement works at Ketton, near Peterborough.

In 2000, the English, Welsh and Scottish Railway (EWS) was short of power and hired in a pair of DRS Class 37s to work a daily empty MGR to Ayr Falkland Yard and a loaded MGR back to Carlisle. On 6 April 2000, 37609 and 37607 pass Polquap Summit with the loaded MGR that they would take only as far as Carlisle, and an EWS locomotive would then take the train to Fiddlers Ferry power station at Widnes.

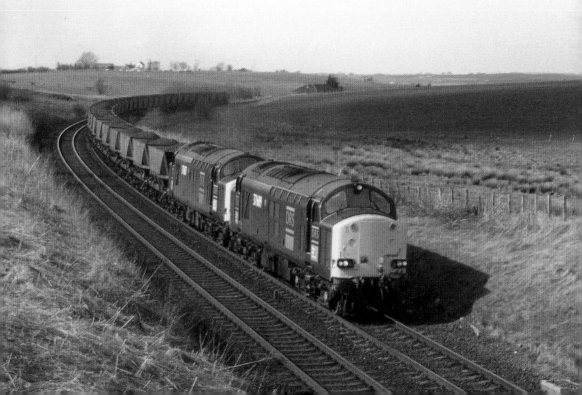

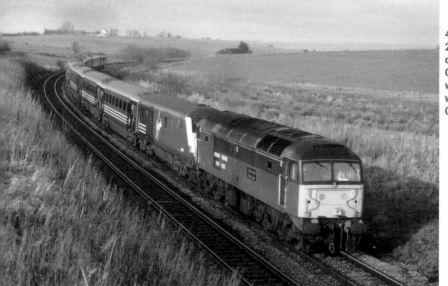

47790 passes Polquap on 28 January 2001 with a diverted 12.03 Glasgow Central to Euston Express, with 87007 on the rear to work the train south from Carlisle.

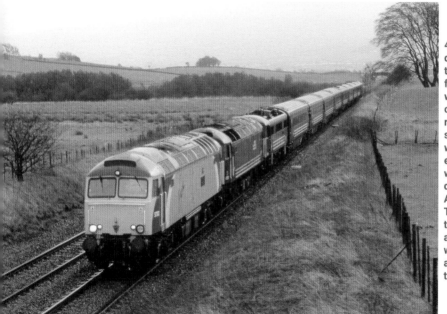

47810 was working the diverted 07.30 Euston to Glasgow Central from Carlisle, when its windscreen wiper failed on a day of very heavy rain. The 47 took the train slowly to New Cumnock, where a 'Thunderbird' engine was based for when services were diverted via the G&SWR. After attaching the Thunderbird Class 57, the train continues north and approaches Polquap with 57312 hauling 47810 and electric 87010; a rare triple header!

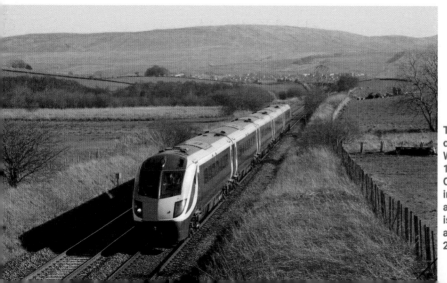

This is an unusual sight on the G&SWR; Great Western Class 180 180108 is running from Old Oak Common depot in London for attention at Glasgow Works and is photographed as it approaches Polquap on 26 March 2012.

An even more unusual and unexpected event is the use of two Caledonian Sleeper Class 73s, 73969 and 73968, on the Royal Scotsman empty stock from Carnforth to Kilmarnock works on 18 March 2016, photographed just before sunset at Polquap.

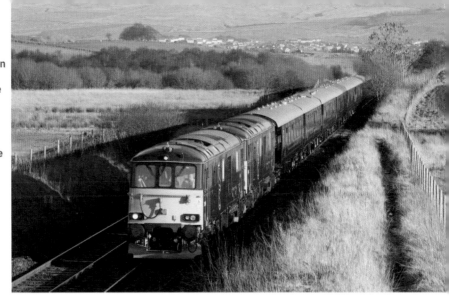

66613 approaches Polquap on 22 February 2010 with an empty Freightliner MGR from Carlisle Yard to Killoch.

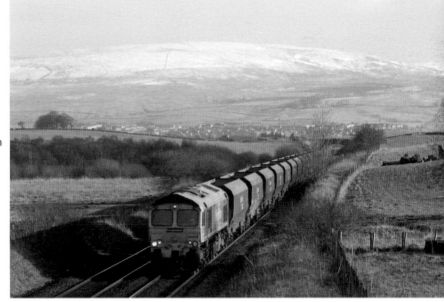

57305 approaches Polquap on 22 February 2004 with the 07.30 from Euston to Glasgow Central; the Virgin coaching set was the wrong way round, with 87001 on the rear. After arriving in Glasgow, the set was turned by taking it for a run around the Hamilton Circle before it returned south.

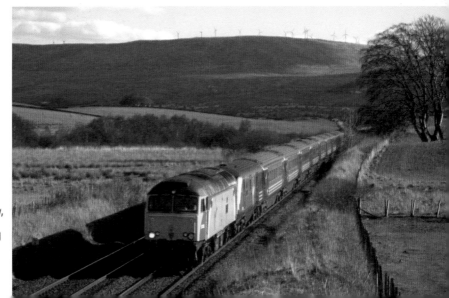

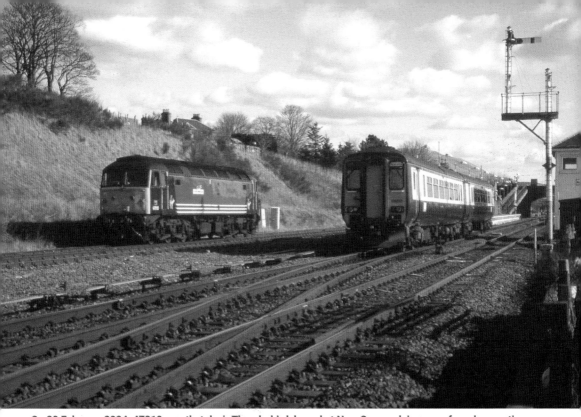

On 28 February 2004, 47810 was that day's Thunderbird, based at New Cumnock in case of any locomotive failures on the G&SWR with the diverted services. The Class 47 is sitting almost opposite the signal box as 156512 passes with the 10.00 Stranraer to Newcastle service.

66193 is on an MGR that was being loaded at New Cumnock (the site was called Crowbandgate) on 26 March 2003; it would depart later that day to Drax power station.

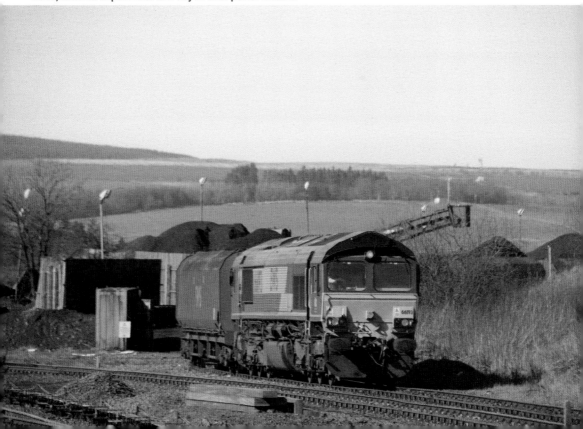

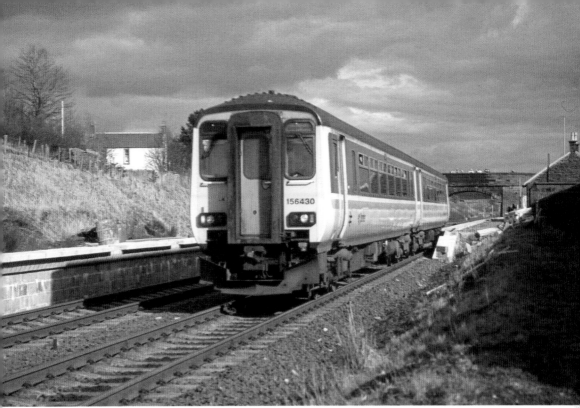

The original New Cumnock station had been closed in the 1960s, but after it was agreed to reopen a station there, work was under way building the new platforms when 156430, in Regional Railways livery, passed through with a Carlisle to Glasgow Central service on 23 March 1991.

On 24 April 2021, 156433 departs from New Cumnock with the 10.13 from Glasgow Central to Carlisle. The Class 156s have worked all the G&SWR stopping passenger services since being introduced in the late 1980s.

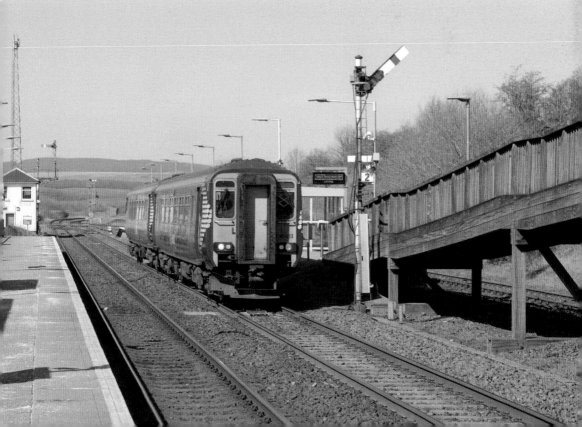

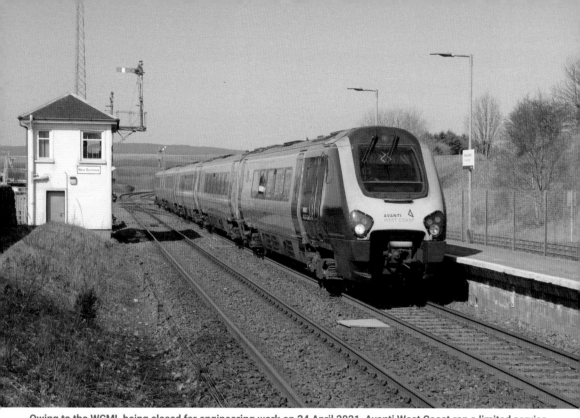

Owing to the WCML being closed for engineering work on 24 April 2021, Avanti West Coast ran a limited service between Glasgow Central and Carlisle via the G&SWR line. 221103 is photographed as it passes through New Cumnock with the 09.57 from Glasgow Central to Carlisle.

A loaded MGR from Knockshinnoch loading site to Cottam power station, comprising four-wheeled hopper wagons, is seen just south of New Cumnock behind 60057 on 6 May 1998.

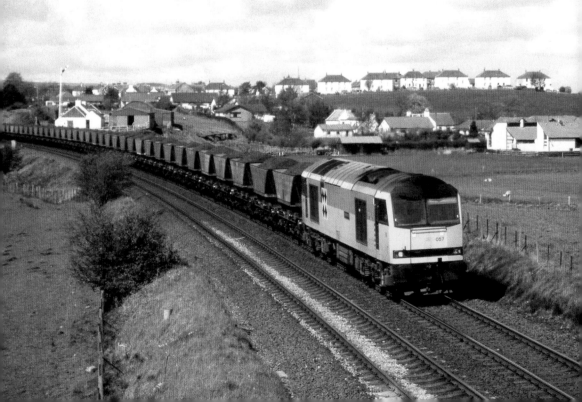

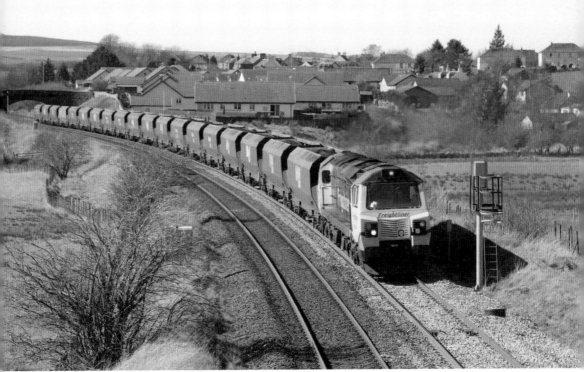

By 2012, all the freight companies that were involved in moving coal were using large bogie hopper wagons. These new wagons were similar to the ones used by Freightliner Heavy Haul in this Killoch to Drax loaded MGR that has just passed New Cumnock behind 70004 on 26 March 2012.

For almost all of the first two months of 2016, the WCML was closed while the severely damaged viaduct at Lamington in the Clyde Valley was rebuilt. Numerous freight services during that period had to be diverted via the G&SWR, and on 3 February 2016, the 06.06 Mossend to Daventry intermodal has just passed New Cumnock on its way south behind 66043.

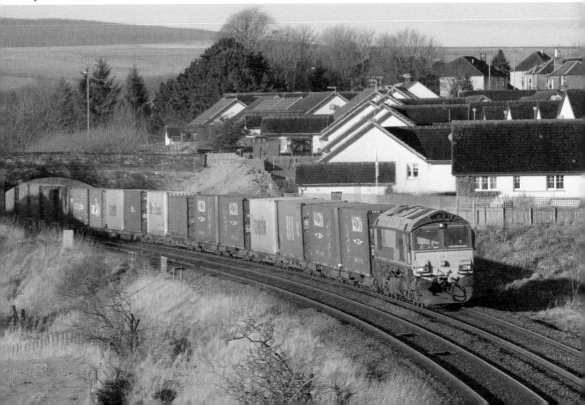

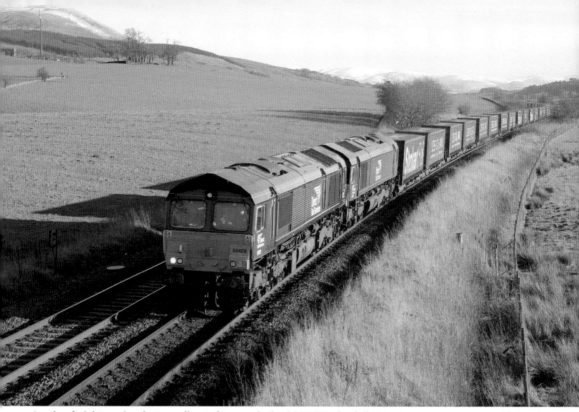

Another freight service that was diverted to run via the G&SWR is the daily 06.16 Daventry to Mossend 'Tesco' intermodal, seen as it approaches New Cumnock on 14 January 2016, behind 66429 and 66426.

A pair of Colas Class 47s on a stock move to the works at Kilmarnock on 20 December 2011 is an unusual choice of power. 47739 and 47749 are seen with a rake of First Great Western coaches as they approach New Cumnock on 20 December 2011.

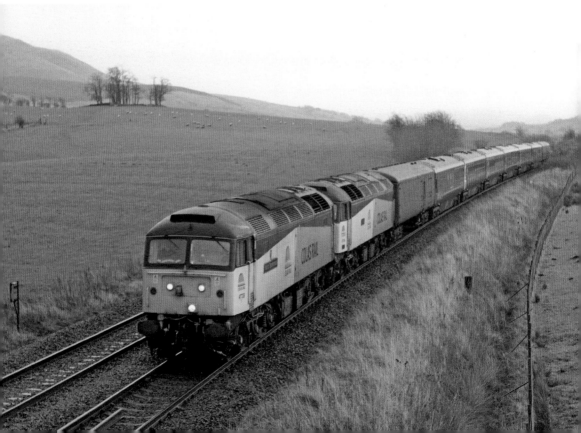

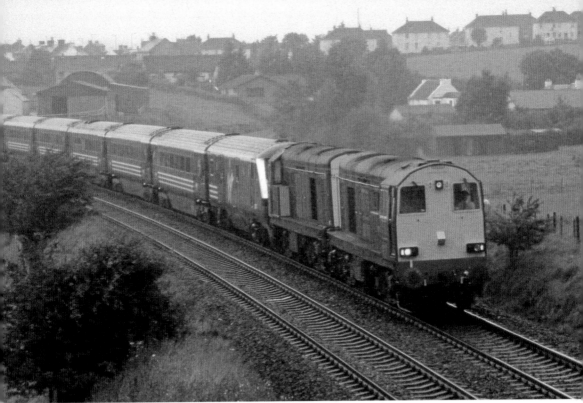

This was one of the most unusual workings that I have ever photographed! On 3 August 1998, an accident closed the WCML, and traffic had to be diverted via the G&SWR line. A shortage of locomotives and crews with the necessary route knowledge caused a pair of DRS Class 20s to be removed from their freight train and sent to Glasgow Central, where they then took the 12.00 Euston to Carlisle via the G&SWR. As the Class 20s had no electrical train heating or power, it must have been an interesting experience travelling on the 12.00! In a strong wind and very heavy rain, 20306 and 20310 pass New Cumnock on their way south.

On a passenger working between Carlisle and Glasgow Central on 3 February 2016, Voyager 221107 is running north in the infant Nith Valley with the 11.00 from Carlisle.

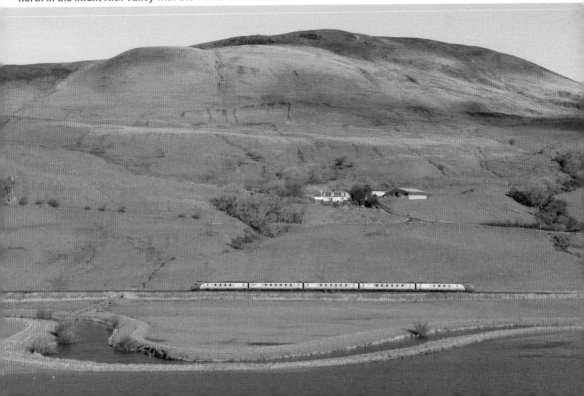

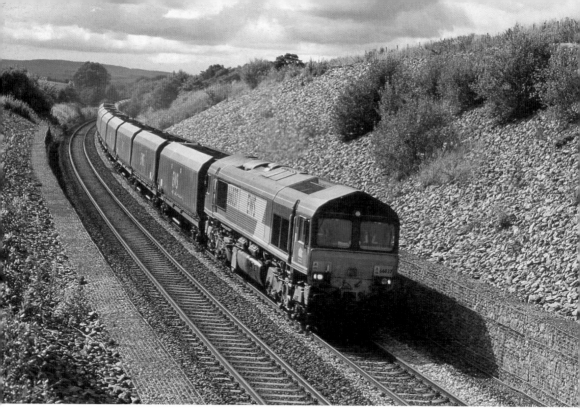

66037 is passing the site of several landslips at Glenmuckloch, between New Cumnock and Kirkconnel, on 13 August 2009 where the cutting sides had had to be stabilised. 66037 is working a New Cumnock to Drax power station loaded MGR.

Another loaded MGR from Falkland Yard to Drax power station heads south past Kirkconnel signal box on 4 March 2000, behind 66124. The rather bent-looking coal wagons in the siding had derailed a couple of weeks earlier because of a faulty axle on a wagon, and were waiting to be taken away either to be repaired or to be scrapped.

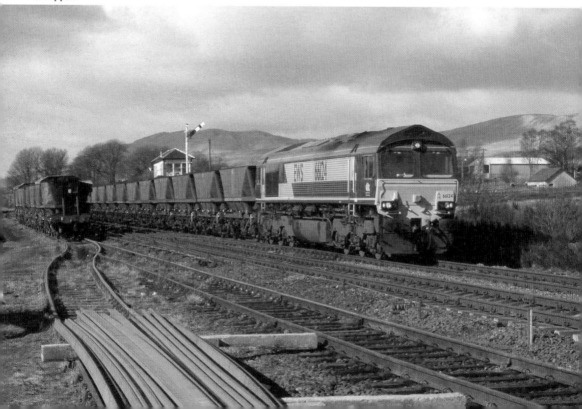

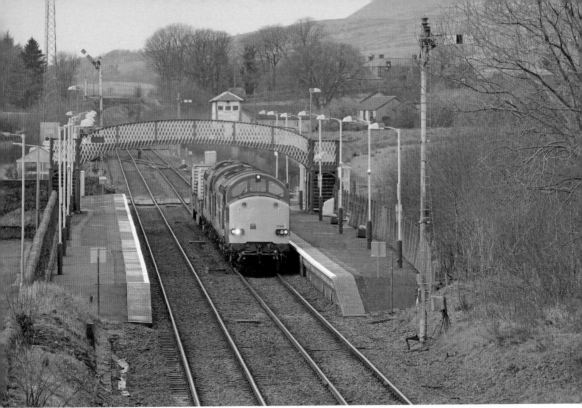

37069 and 37609 are waiting for the preceding train to clear the section to Thornhill before they can resume their very long diverted train: the 06.24 from Seaton to Sellafield on 3 February 2016. Owing to the Tyne Valley line being closed, as well as the WCML, they had had to travel via Edinburgh and Glasgow before their journey down the G&SWR.

156434 arrives at Kirkconnel on 24 April 2021 with the 13.13 from Glasgow Central to Carlisle. The tall home starting signal seen in the previous photograph has now been replaced with a much shorter signal, complete with a white board to improve sighting.

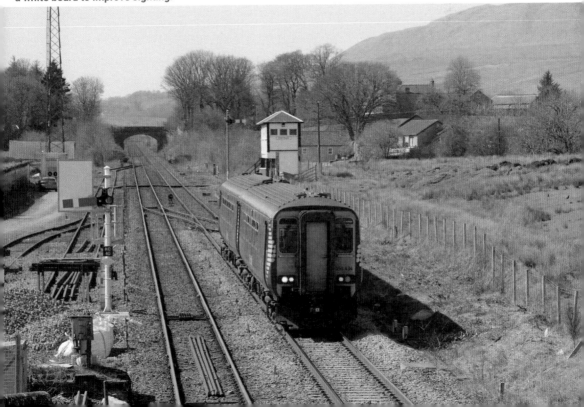

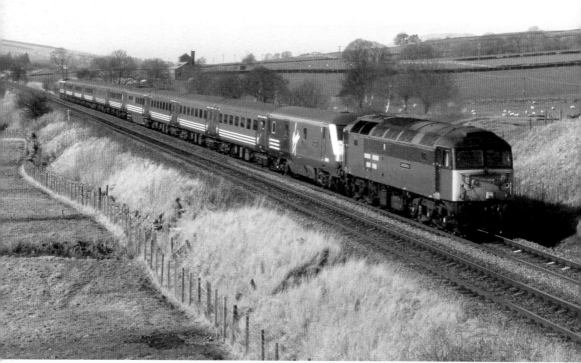

47789 passes Gateside on 15 March 2003 with the 10.00 from Glasgow Central to Euston. It also has 90004 on the rear to take the train south from Carlisle, where the Class 47 would be removed.

66524 passes Enterkinfoot on 22 November 2001 with a loaded MGR from New Cumnock to Eggborough power station.

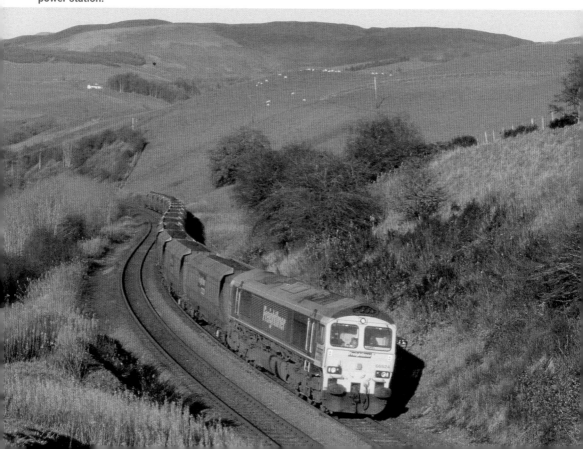

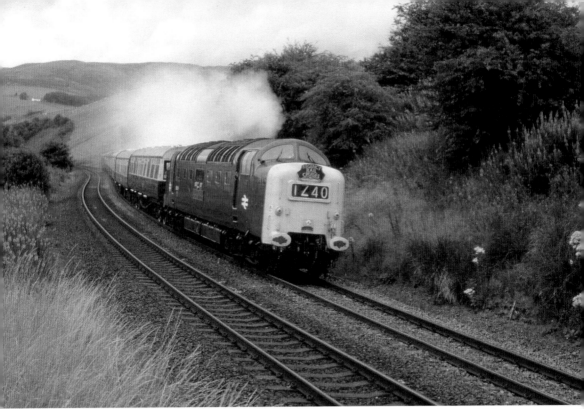

Deltic 55019 is powering a Glasgow to Bristol Regency Railtour south at Enterkinfoot on 15 August 1999.

With 87033 on the rear, Virgin-liveried 47841 passes Closeburn with the 08.03 from Glasgow Central to Euston on 6 March 2004.

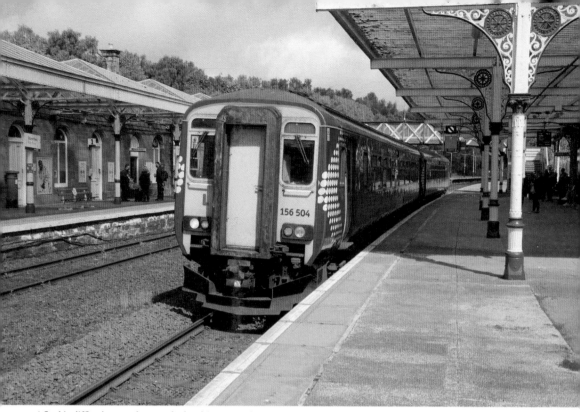

I find it difficult to understand why this particular working happens. The majority of stopping passenger trains on the G&SWR are through trains between Glasgow and Carlisle, but not this one. 156504 had worked the 08.23 from Glasgow Central to Dumfries, where it arrived at 10.34. Upon arrival, all the passengers have to leave the train and wait on the platform until another crew arrives, starts the engines and opens the doors. The train then departs at 11.01 to Carlisle! The 156 is seen as it waits at Dumfries on 27 May 2021.

66155 runs west on the then single line between Gretna Green and Annan on 4 July 2008. The former double-track main line had been singled as an economy measure, but because of the number of coal trains that were running at that time, it was decided to redouble this section and work was under way when 66155 passed with the 13.08 empty MGR from Lynemouth power station to Falkland Yard.

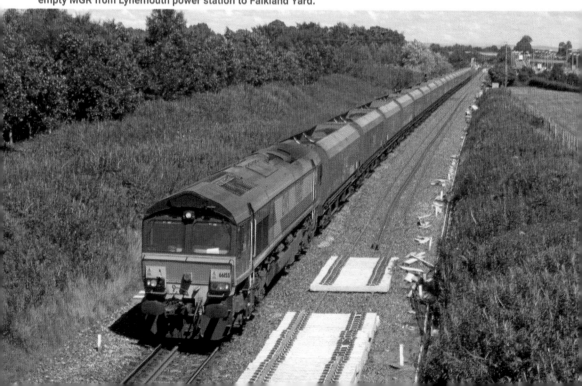

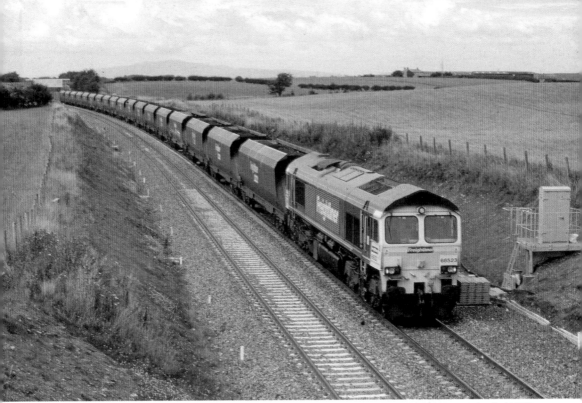

With the new down line now laid, 66523 approaches Gretna Green on 8 August 2008 with the 04.55 loaded MGR from Hunterston to Carlisle Yard.

66411 *Eddie the Engine* in its Stobart livery runs west on the new line on 25 April 2009 with the 05.05 Daventry to Grangemouth intermodal.

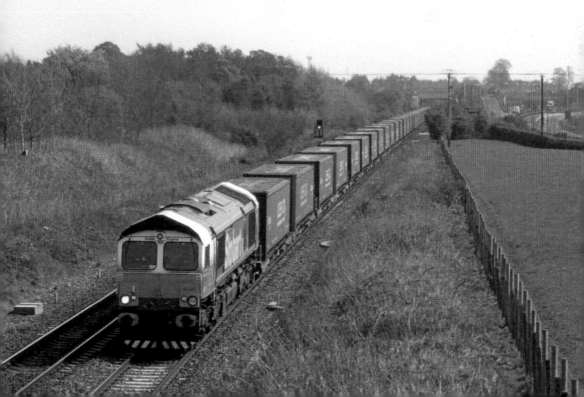

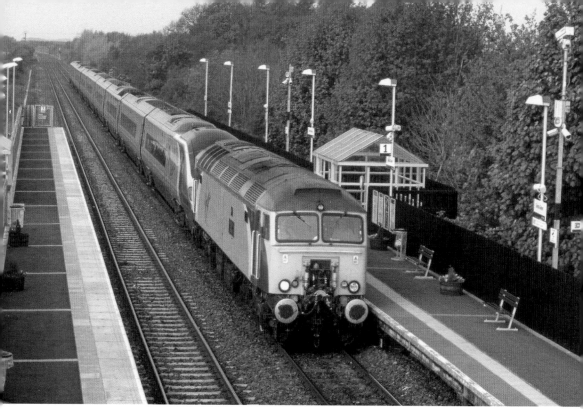

57310 has Pendolino 390025 behind it as it runs through Gretna Green station on 25 April 2009, with the 08.00 from Glasgow Central to Euston. The Class 57 would be taken off at Carlisle, and the Class 390 would continue its journey south on its own electric power.

Further reading from

As Europe's leading transport publisher, we produce a wide range of railway magazines and bookazines.